# Railroad Voices

# Railroad Voices

*narratives by linda niemann*

*photographs by lina bertucci*

STANFORD UNIVERSITY PRESS

STANFORD, CALIFORNIA

1998

Stanford University Press
Stanford, California
© 1998 by the Board of Trustees of the Leland Stanford Junior University

Printed in Korea

CIP data appear at the end of the book

*In memory of Josie Cole*

LINDA NIEMANN

*To all the men and women of the Milwaukee Road*

LINA BERTUCCI

I would like to thank Carter Wilson, Dorothy Mohr, and Audrey Stanley for reading and commenting on my work. Also Bob Blinkenberg, Gary Beller, Bill Sheehy, Josie Cole, Mary Alsip, Rich McGraph, Bob Kreiberg, Cindy Angelos, Pat Doolette, Rolling Thunder, Bob Coyne, the Conradi family, and Keith Rowley for interviews and conversations.

A version of "The Verdi Gang" appeared in *Amtrak Express*, February, 1991.

LINDA NIEMANN

I would like to thank Cindy Angelos for her endless enthusiasm and support on this project, Ed Ehrlich for recalling much of the jargon, Karina Bertucci for the memories, and Francesco Bonami, my husband, for his support and love.

LINA BERTUCCI

In October 1994, I was lying on my couch in Santa Cruz, California, watching a sycamore go green in the field across the way. I marked it because I was about to begin taking chemotherapy pills for a six-month journey into the underworld, and I thought it would do as an emblem for the changes my own body would go through. It reminded me of the winter I spent working the east line from El Paso to Carrizozo, New Mexico, watching the cottonwood trees that gave Alamogordo its name lose their leaves and stand dry and sticklike beside the tracks, until in April they were green and fat again with the *sangre verde*, the green blood, of the earth lord.

I had already decided to abandon my personality for this period and go into myth. I decorated my room like a sandpainting. I began to have animal dreams. I painted and sewed costumes of what I remembered. In spring, when I planted a corn field and held a ceremony marking the return to green life, the sycamore tree was releafing and my dreams abruptly shifted from the mythic to the mundane. The night after planting I dreamed I lost my suitcase in the airport. Welcome back to the world.

On the couch in October, however, I had nine months of inactivity before me, and I was beginning to wonder what I should do with it. At about ten o'clock at night I received a phone call from a woman introducing herself as Lina Bertucci. She had just read *Boomer: Railroad Memoirs* and wanted to

tell me about her experience of working as a switchman on the Milwaukee Road in the seventies. She had photographs, as well, and offered to send them to me with the idea that it might lead to a collaboration. It seemed too serendipitous to pass up. Weeks later, 160 slides arrived, and I looked in on the faces and railroad settings that appear in this book. They were true to the life. These were the people I worked with; these were the places I worked in. And they were good.

Over the winter I constructed a frame from my eighteen-year railroad career, not captioning the photographs but giving them voice and context. Over the years I have documented, like Lina, the craft I found myself in, collecting taped interviews with other rails and creating narratives out of working life. Our two perspectives are similar. But then, they would be. We were both on the other side of the same kind of glances, the same kind of resistance. What is interesting is the love I find in these photographs for this hard way of life—a love that, I hope, is also reflected in my text.

For those readers unfamiliar with railroad lingo I have included a glossary.

LINDA NIEMANN
*Santa Cruz, California*

Twenty years ago I was hired as a brakeman on the Milwaukee Road. As one of the first women to break into that all-male enclave, American railroading, I stepped into a world strong in its tradition of male bonding and fierce independence. The job was hard, at times even perilous, yet it offered me the chance to observe the male gaze and to document an era in railroad life that was slowly beginning to fade.

In those freezing days along the tracks, with my camera tucked inside my bag, I often felt like "the girl with the camera," hoping to fit in. Working on the engine or in the caboose, or switching cars with the crew, I lost track of genders and roles and tried to live my days as just another brakeman. Yet I carried on this project, part of me convinced that one day, with the passing of the years, these images would stand on their own, as a record of a time

when the legacy of railroading was still an integral part of American life but when signs of its neglect had begun to appear.

Twenty years needed to pass before I would regain the vision I had, the project I had pursued. I uncovered the negatives, and slowly the images began to reemerge, filling my thoughts with clear, almost tangible, memories. As I looked at the images of these men—their eyes, their wrinkles, their smiles and grins—I again felt the privilege of having been able to record an experience that could so easily have slipped away into teenage memory.

Those photographs, I now saw, were never simply creative memories of a personal experience, but a record of a social and historical moment as well— a moment that had intersected with my own identity as I stood witness to a communal cultural and industrial transformation. But the images before me seemed strangely to seek for their lost voices. I realized I needed to find a way to let them speak, a tool capable of preserving the integrity of that specific time—a text to verbalize them. To do so, I needed to locate a parallel experience, one that only an independent voice could create.

I went back to my former railroad pals, my aunt Cindy and my sister Karina, who both suggested I read *Boomer*, the railroad memoirs of Linda Niemann, a West Coast writer and woman working on the rails. The moment I began reading Linda's book, I was instantly struck by its tone. It had a realness, a heart, that I recognized. This was the railroading I had known. This was the voice I was looking for—a literary mirror that would reflect our worlds. Her words thus became our voice, my pictures an echo of our lives: the cold, the sweat, the yelling and screeching, the pungent smell of diesel fuel, coffee, and stale cigarette butts.

I sensed Linda's vision, and she saw mine. Our thoughts ignite—images and words ride side by side on parallel tracks.

<div style="text-align: right">

LINA BERTUCCI
*New York, New York*

</div>

# Contents

**Railroad Voices**

## The Walls Have Ears

"Everybody had a name—Butterball, Corky, Squirrel, the Buddha, Face Down, Jivey, Wide Load. Old Jockstrap was John Taylor. I don't know how these guys get their nicknames. I know how old High Pockets got his name."

"He had high pockets."

"He was so tall and his pockets were up to here. High Pockets and Wyatt Earp—he was the only guy I remember who had two nicknames. His brother was Jugbutt because, for one thing, his butt was about this big and it looked like a jug and everyone called him Jugbutt. We had a Liberace—committed suicide."

"Senator Claghorn—Old E. V. Smith up in the city. They call him Senator Claghorn after that old rooster, that big rooster that went, 'I say boy.' Smitty always had a pocket full of cigars, and he was always lecturing you, like a senator."

"He tried yardmastering one time and they pulled the pin on him in a hurry."

"Boxhead Doyle and the Broom—Tony Hammond."

"Almost everybody had nicknames—the Ridgerunner, Popoff. They called him the Ridgerunner because he was from Arkansas. I got a big kick out of him—a character—I says to him, 'Where do you hide your mad money from the old lady?'

"'Oh, I got a perfect place,' he says. 'I got a book about snakes and she hates snakes with a passion, so I put the money between the pages. She wouldn't touch that book in a million years.'

"What was that little guy that was ninety years old when he retired?"

"The Little Round Man. He wasn't fat, but he had a little belly right here and they called him the Little Round Man."

"We had Mr. Clean, at the 16th Street shanty. He'd take the hose and hose the whole shanty down—inside, wore white gloves, a suit—Jack Eden. He could get in between a car and lace a whole train and never get an ounce of dirt on him."

"Another guy who was like that—very fastidious—was Lincoln J. Smith, a yardmaster. When you gave him the turnover he wouldn't touch anything, and then after you were gone he would get his little bucket and his spray and he would clean everything—the phones, wash all the desks. Yardmasters don't get no beans, but Link always brought his little dinner, and there was a certain time when there was nothing going on, he'd take his little lunch and walk out of the shanty at Mission Bay and walk around the back and he would sit there, and he would take about fifteen minutes to eat his lunch, and I don't care if the president of the railroad come, nobody bothered him when he was eating his lunch. Now when he got up he was right back to work again, but he'd say, 'I'll be back in fifteen minutes,' and that meant, 'Nobody bother me.'"

"Like I said, we had Wedgehead, Meathead, the Mexican General."

"Joe Manassey—you know we were on a job, me and Al, in the city, and the last thing you had to do was press that piggyback train together in the morning, and it was always right at 6:30 in the morning, and it was always right at quitting time, and I didn't have a watch, because I had a standard clock in the shanty at Mission Bay and all I had to do was look in the window. So I'm down there every morning—we knew this was going to happen—we'd get in there and we'd finish up all these cars and we'd walk by and old Joe Manassey would be standing out there saying, 'Twenty-five after, you guys just made it.'"

"Yeah, Joe."

"And we'd walk around the shanty and they had this window at Mission Bay, you could look up and see into the yardmaster's room, and Al and I would run up there and look, and here would be Joe up on a chair moving

the hand of the clock ahead—it was really about twenty to 7:00—and he'd be moving the hand ahead, so it would show we didn't make any overtime.

"He was a guy that had scroll handwriting, it looked like something that you'd see on a card, but it was hard to decipher because it was so fancy, and old Wild Bill Cassio was there and he comes out and gives Cassio the list, and Joe always wore a nice hat, and Cassio got the list and he turns it around and looks at it, turns it upside down and looks at it. Joe's watching. Cassio says, 'I know you want me to do something but I don't know what it is.' Joe throws his hat off and stamps on it, yelling, "You make me so mad, give that thing to me.' He was a nice guy but he just would get really upset if you said anything about his handwriting.

"I was in there making the coffee, and I says, 'Joe, why don't you print? I can't read this. This don't make no sense to me. Is it Mexican?' And he says to me, 'That's the Queen's English.'"

"They were characters. The old days in the city. There was this bar—the Shamrock—all the rails used to go there. . . . Tony comes in the door and says, 'Anybody in here got a bigger dick than me, I'll buy you all drinks.' This little guy sitting down the bar gets up and whips it out on the bar. Tony took one look at it and says, 'What's everybody drinking?' I was sitting right at the bar when that happened. Swear to God."

"We used to have to make out a Form 16—conductor's work report. You had to write down all the cars you spotted, and old Al Barry and I were on the job—we both had two jobs. I had to paint houses during the day and Al had to be a gardener. We go to work and I'd get there at 10:00 P.M. for an 11:30 start and we go down through the sheds and hand-buckle up all the cars and I'd go up to Acme Fast Freight and help open all the doors and get the plates in them and John always had the coffee and donuts ready, and then I'd go down to Walzack, the yardmaster, and get a stack of lists this big, and Al would come in and I'd give him a list, we'd go outside, pull forty cars, go to coffee. After that I'd call Mission Bay and we'd go over there. They had two rails. We'd get them together, get the list from Virgil, make out the Form 16. Well, we tried to get done by at least 5:30 or 6:00 so we could sleep a little for an hour. Jim Bays would come in every morning and I'd have my pillow over the phone and I had the phone right under my ear and I had cable radio on. Bays would come in, get the list, and say, 'Anything left to do?' Barry sits up—you know how he swore—'That cocksucker,' he says, 'you

look at them lists. A hundred-one cars and we done a hundred of them. There's one that he didn't shove under the dairy. We had to leave the day brothers something.'"

*Gary Beller, switchman*
*Bob Blinkenberg, yardmaster*

Waiting for more lists of work to do and while the foreman is making his plans, crews sit around in the shanty, a huge lockerroom with long tables and coffee machines, strewn with litter, safety posters, and picnic announcements. Now there is a bank of computers and printers that switchmen use to check the extra boards, their pay records, and to sign on and off. Outside is usually a well-used Weber barbecue.

Often working eight hours on and eight hours off, a switchman might leave the shanty at 3:00 in the afternoon, return at 11:00 at night, and leave again at 7:00 the next day. They repeat this schedule until they collapse, often on the benches of the shanty or in their campers in the parking lot. In order to make overtime shifts, many switchmen never lay off, also driving for hours on the freeways to work so that they can have the desirable middle-class homes this overtime buys. In the old days of sixteen-hour shifts, switchmen literally lived in the shanty, and when I hired on in 1979, it still had the feel of a boys' clubhouse—no girls allowed.

## The Yard

On the wall of every railroad yard office is a map of the United States with that road's track system marked out on it. The Southern Pacific lines resemble a root system branching out from Chicago coast to coast and down to the Gulf and the Mexican border. Paralleling old river routes and old cross-continental trails, the rails follow the mercantile road from container ports, oil fields, coal and copper mines, and lumber, cattle, and lettuce towns. The map of the rails also maps the years I have spent at these locations in seventeen years on the road as a baby brakeman. I get lost in the names—Klamath Falls, Dunsmuir, Roseville, Sparks, Odgen, Oakland, Tracy, Fresno, Bakersfield, San Jose, Watsonville, San Luis Obispo, L.A., Colton, El Centro, Yuma, Tucson, Lordsburg, El Paso, Carrizozo, Tucumcari, Houston.

Most terminals have a small switching yard where the local freight gets assembled into blocks of cars that main-line trains pick up and carry on across the country. The express train hotshots, like the Memphis Blue Streak, smoke on past these small yards, often carrying one cargo directly from the container ports to major cities. The luck of the draw decides who gets to ride these hotshot trains and who gets to ride the twelve-hour dogs that sit in the sidings waiting for them to highball past.

At certain points on the map of the system ganglia appear—major switch-

ing yards with hundreds of tracks to sort out traffic going in the four directions. Such a yard is a whirlwind mandala, a sand painting in constant motion, a hub, a center. The Southern Pacific has Roseville in the north, Colton in the west, Tucson in the south, and Houston in the east.

I have worked in all these yards, and I remember my first day in each of them—armed with a switch list and only the vaguest idea of where in the maze of tracks our cars were supposed to go. Working these yards you would be lost for months, the confusion compounded by working at night and the fact that the tracks were rarely numbered. Knowing such a yard well took years—the local switchmen spent forty-year careers of sixteen-hour days living in them. Added to the confusion in a new place was the element of fear: switching yards are always dangerous places, and any mistake could kill you or someone on your crew. A new yard was exponentially more dangerous. Each boxcar is the size of a house, and tracks full of them can move unexpectedly as rolling cars crash into the tracks. You can be walking a track at night when suddenly the track next to you lurches and the slack starts its domino run. The sudden rupture of the silence startles you and, no matter how experienced you are, you jump.

When I hired out in 1979 as a switchman in the Watsonville freight yard, my last job had been teaching literature at the University of California. I had a Ph.D. from Berkeley, and I suppose the archaic appealed to me. The ad "BRAKEMEN WANTED" in the Sunday paper sounded romantic and interesting. Three months later, I found myself on the east lead job in a rainy October with the two other women who were in my railroad training class. We were known as the all-girl crew. We would arrive for work at midnight and wait for Keith, the yardmaster, to send us a switch list, which was dropped into a pipe in the yardmaster's tower known as the tube. The list fell by gravity to the bottom of the tower, where the foreman, Charlotte, would retrieve it. It listed all the cars in the yard by track, and next to the cars Keith would mark the tracks they were going to. Our job was to get them there. The tracks we switched out comprised the locals that went on duty in the morning—the Santa Cruz, the Peddler, and the Monterey.

"I'd give Charlotte a list in the tube, and I'd no more get it out of my mouth than I'd see that shanty door open and there she goes and gets the list and comes back and she'd no sooner go in than everybody's coming out and

I'd say, 'Wait a minute, let's talk this over, let's see what we're going to do.' But you didn't lack enthusiasm. It was a lot of fun.

"I used to get a lot of comments about it. Some of the old-timers. They didn't even like women working, period. But some of the old-timers, when I hired out they wouldn't talk to me or the other guys just hired out—they'd think I was taking their job, and I guess it was because they used to work on their days off, and they'd think, 'I got this kid here and I won't be able to get any overtime.' The old-timers—they didn't like anybody, didn't like each other, didn't like themselves, even.

"I used to tell you to hold out your double head-enders here, then you make a cut, come out with this car here, throw your couple of head-enders to track 8—now you're holding triple head-enders—put them back against the train you're switching and they're right where they belong—against your engine. Next time you come out, you could switch your double head-enders against the single, the triples back again back into your train—that put the triples on the head end and when you pick up the doubles, the singles were right behind it, so when you double those in. . . . Like I say, that's why I used to try to go down and talk to you and tell you what we were doing, and it was raining and your list gets wet—that's why we had the speakers, so I could talk to you and tell you, 'That car's going wrong.' Most of the time I could see from the tower, but I have been up in the tower when that tule fog—that ground fog—was so bad that the sun was shining up there—you could see the moon and the stars in the tower, and you couldn't see the ground. Especially before you had radios, you had a fifty-car train to tie up and you had to use fusees and you couldn't see. It was kind of hard to ask the engineer to keep on going until he hit something."

*Keith Rowley, yardmaster, Watsonville Junction*

"I was going to be finishing up my bachelors in January and I wanted a job that paid a lot of money. I ran into a friend at the university snack bar— he hated to work, just hated to work—and he said, 'I've got the greatest job, I just got a job on the railroad, I'm working as a switchman, I make lots of money.' That was the thing for me. I said, 'Could I do it?' He said, 'Sure, I don't see why not, you'd be the only woman, but I don't see why you couldn't.' So I went down and applied for the job. I had no idea what he

did—he didn't explain much, just that he went on trains. It was April of 1974, and I went into the office of the trainmaster, and he proceeded to interview me for two hours—he told me the bathrooms were filthy, and that I would get dirty on the job, I wouldn't get to wear pretty clothes, that I would hear swearing, that I would have to work at night and not in a clean environment like the office. My question after each of these questions was, 'Is the pay the same as for the men?' And the answer was, 'Yes.' This went on for two hours and he finally said, 'O.K., you can come down and go through the training session, and if everything works out, fine.'

"That's what I did—two weeks later I went down and I got there and there was supposed to be eight of us in the training session and one person didn't show and the trainmaster asked his secretary who else they could get and I said Lina Bertucci could apply and he said, 'No, no, no, we don't want to do that.' And I said, 'I know she's home and she doesn't live very far and can get down here right away,' and Lina came down and entered the training course there and then."

*Cindy Angelos, first woman conductor on the Milwaukee Road*

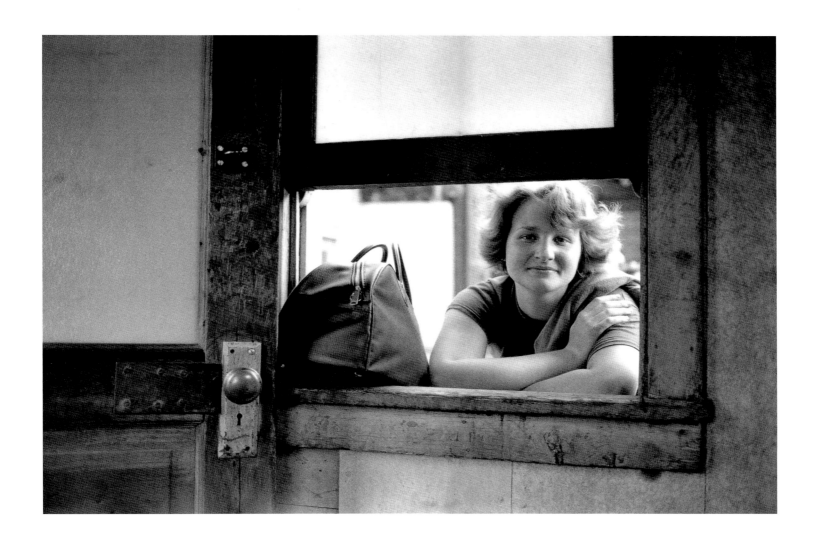

brakewoman on the road

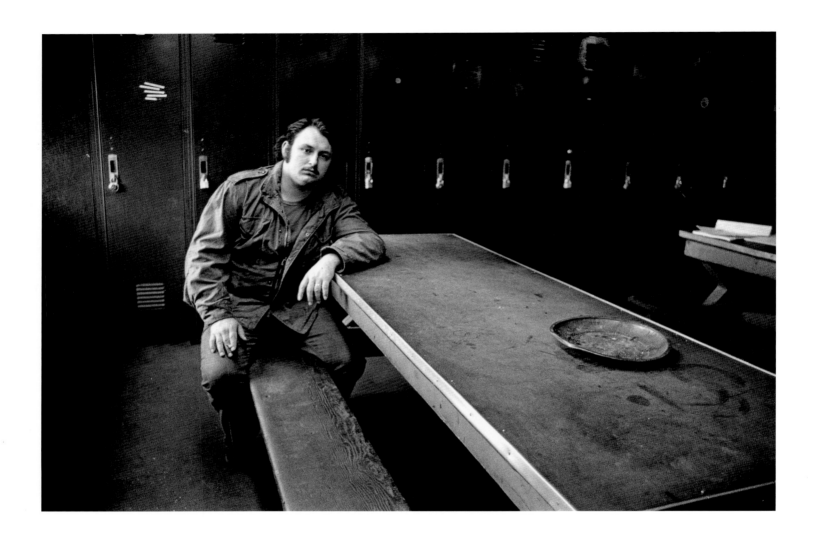

switchman at table

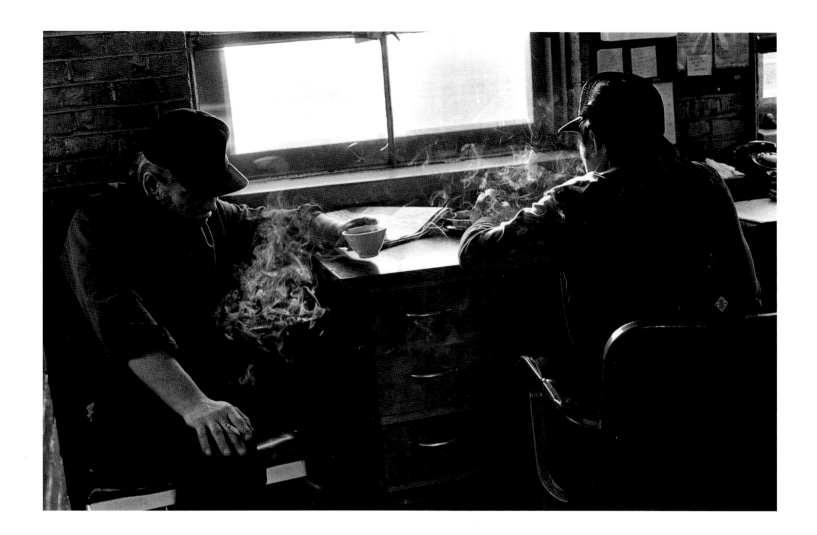

afternoon break

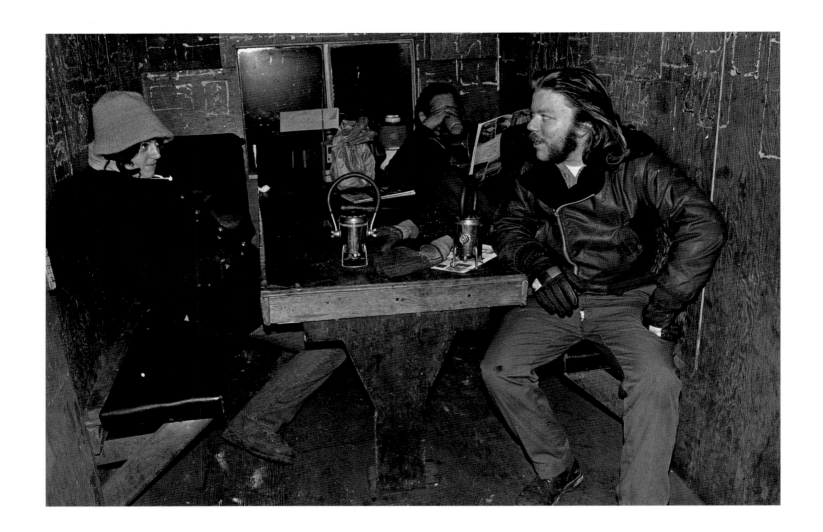

night crew

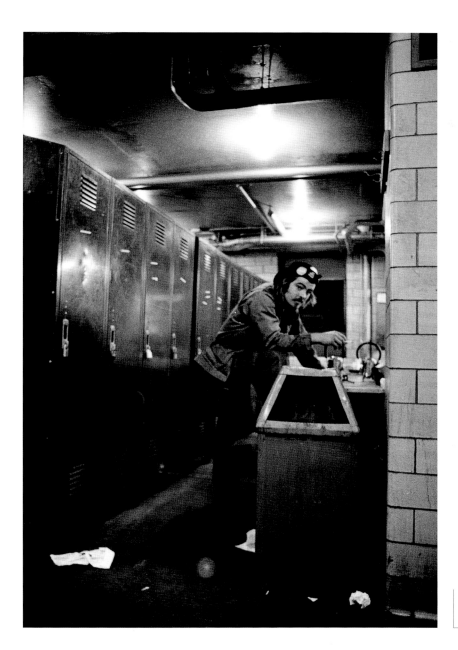

night yardmen

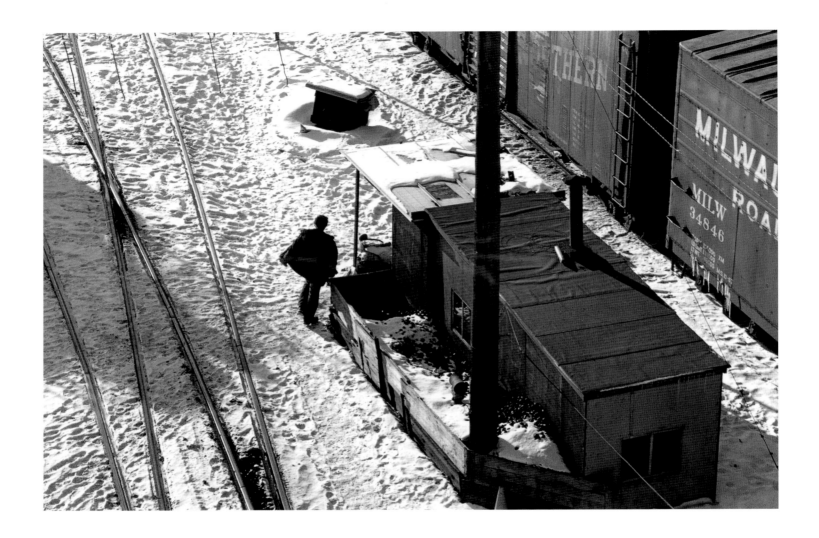

heading for shelter

## Booming Again

My first night back in the Colton yard after ten years was in a summer so hot that Tarahumara children died from the drought in the Sierra Madre of Mexico eight hundred miles south. I was called for a trim job on the midnight shift, sitting on the long bench, lantern in hand, gloves out, safety glasses on, nobody talking to me since I'm sent down here from somewhere else on the region-system board, a company-sweet deal that lets them send me anywhere they're short twenty days a month—putting me up in some fancy motel. But I'm not wanting to have to break in everywhere all over again after fifteen years on the job. And an old head comes in the door, looks like Abraham Lincoln, the first words out of his mouth—"All right, I admit it. I did it to myself. I know I'll never hear the end of it on this railroad, probably the first time in recorded history anyone has ever kicked a boxcar into his own truck."

"O.K., Lester." A voice came from a darkened area behind a row of lockers. "How'd you do that?"

"Well, I kicked the car pretty good, got it rolling pretty good—too good, in fact, and I was going to chase it down with my truck to tie a brake on it. Well, I was crossing over in front of it when the darn truck stalled on the crossing and the boxcar hit it. Dented the crap out of the door."

"Well, where was you at the time?"

"I was in the truck. I know. I told the trainmaster, and he just looked at me and said he guessed they could take care of the door, and I said, 'That's all I want.'"

I really appreciated Lester that night. After that story, a woman switchman from somewhere else was no big deal.

## Baby on the Board

In 1972 the seniority rosters of brakemen and switchmen on the Southern Pacific railroad were combined. Anyone hired before that date got protection in their own craft at their home terminal. After that date, anyone on the Southern Pacific system with a better seniority date could come into your home terminal and bump you or take your job. No woman has a protected date, since we were excluded from the profession until the late 1970s. The term "baby on the board" refers to the switchman or brakeman with the least seniority on the extra board—the list of available people on call for vacancies. After seventeen years on the railroad, I am still the baby in my home district. Out of seventeen people in my class of 1979, I am the only one still working in my craft in the place where I hired on. There has not been another class on the coast since then.

Since 1979 crew size has been reduced from two brakemen on every local job to one, and in through-freight service to conductor and engineer only. I am the missing brakeman. Yard crews shrank to one switchman and a foreman. The foreman or the conductor now do the missing clerk's job also, using a laptop computer called a "gridpad" to enter their daily reports and fax them to the computer operations center.

To keep up with this kind of job attrition, the babies on the board have had to do every kind of railroad work in every location—if they wanted to

keep working. When I was cut off the Watsonville brakeman's extra board I transferred into the yard to work as a switchman. When they closed the Watsonville yard, I drove eighty miles each way to work jobs off the San Francisco or Oakland brakeman's extra boards. When I couldn't work anywhere close to home, I transferred to wherever I could work, becoming a "boomer"—someone who follows the work across the country. When Amtrak decided to hire their own crews in 1987, I loaned out to them for several years, working the Coast Starlight, the California Zephyr, and the San Joaquin route. When we got a little better contract protection, I went back to freight. When I needed more regular hours, I worked the commutes between San Jose and San Francisco. Under the region-system board established in 1994, I was force-assigned for twenty days each month to whatever location the company deemed had a shortage—Roseville, Oakland, El Paso, Los Angeles, Colton, or Phoenix, spending my ten days off each month at home. Recently I have transferred to a shortage yard in San Jose, taking a big cut in pay to have a home base again. I do these acrobatics just to stay working, as do my fellow railroaders.

Traditionally, the baby on the board would have to put up with this kind of uncertainty for four or five years in his career. Now it has become the job description. My life, twenty-four hours a day, seven days a week, belongs to the Southern Pacific railroad. "Hey, kid," my foreman tells me, sixty-five years old with forty-four years seniority, "Get your rest."

"It turned out that when we got the job, we were going to go on the road. Because we had seniority in so many different yards in Wisconsin and Illinois and we were on the extra board, we got a whole variety of assignments right off the bat. We worked out of Milwaukee through-freight or work-trains between Milwaukee and Portage or Milwaukee and Bensonville—a suburb of Chicago—and sometimes up to Minneapolis. We worked passenger jobs out of Milwaukee or Chicago on Amtrak. I went to get a uniform at the company's uniform maker in Chicago, and they said, 'Oh yes, we know what you want.' When I picked up my uniform, I had the zipper on the side. That was the change. The crotch was down to my knees—they made it for ballroom. I looked like an absolute clown, it was cut for a man completely. I looked like an idiot in this thing. And we had the male hat. We looked like we were in Halloween costumes.

We also worked on suburban trains from Fox Lake, Illinois, to Chicago, and because Fox Lake is about sixty miles from Milwaukee and, of course, the trains were commuter trains, we were on duty at 4:30 or 5:00 in the morning and it usually meant leaving here at 3:00 to get there. We also worked in different terminals—at one time I was assigned at a terminal in southern Illinois for a couple of weeks. What I found was that each time, every time I thought that the men had finished testing me, I'd get sent to a new terminal or place where I was invariably told, 'Well, this railroad ain't like the railroad you know. No woman could work here.' Wherever we went, it was always 'different,' and no woman could possibly do that. We learned later that there was a conspiracy by the engineers to not tell us that there was a toilet on the engine. We did not know for two months that there was a toilet on the engine. Then, finally, one engineer, who was the fatherly type, let us in on it."

*Cindy Angelos, Milwaukee Road conductor*

## Passenger Train

I was working the night Coast Starlight out of Oakland. It was passenger service, and I still wasn't used to it. I had ten years in as a freight brakeman and I was still the baby on the extra board, so I loaned out as a conductor on Amtrak. My regular run was Oakland to Klamath Falls, a twelve-hour all-nighter up the Sacramento River valley. I now wore a three-piece blue suit, and I didn't have to get rained on at work anymore. It should have been a cushy job. But I missed the solitude of working freight, and passenger work was hard for me. I knew about all the things that could go wrong with trains, and I was used to sitting in a siding for hours waiting for a signal to change. Passengers worried about delays, but I was happy if we were moving at all. The night train wasn't bad, since most of the passengers were asleep. There were just the drunks to deal with and the night stops and the ones who wanted to stay up all night and talk.

Klamath Falls in winter was a lunar snowfield a mile high overshadowed by Mount Shasta, an active volcano. I had a clarity of mind when I was deposited here once a week. It was as though now I could think about certain things that were buried normally, and my body felt new as I walked in the cold to the store or beside the strange, green, hairy-weeded river.

Klamath Falls was one vertebra in the long spine of the Cascade range—volcanic solitaires dominoed from Lassen in the south, to Shasta, Hood, St.

Helens, and Rainier. Childhood memories connected me to these places. One summer on a family vacation, my mother rented a canoe and took me out on Spirit Lake below Mount St. Helens, paddling on a diagonal to a cove on the far shore. I could feel her joy, and also how hard it was to pull against the wind. When she was young, she was taught by guides in her grandmother's summer house, on a lake in the Adirondacks. They paddled birchbark guide canoes that were kept in a boathouse on the docks, upside down on long racks. The grandmother was Irish Catholic and warned about the Devil that lived in mirrors and looked back at small girls. But small girls could learn to paddle canoes, could go out on the lake with boatmen, could float on the mirrored surface of the water without fear.

The westbound Starlight was due in at 10:00 P.M., and it wasn't now quite so cold, or the cold was more in harmony with the night, the darkness peppered with starlight and the ghostly luminescence of the volcano. There weren't many passengers, and the baggage was light. Just a few suitcases and two Christmas trees the engineer was taking home. I liked the way they filled the baggage car with a pine smell. I climbed on as the Portland brakeman was climbing off.

"No mail for Dunsmuir in the head car. You got room for the night stops in the eleven car. But you got a few drunks and one nut without a ticket. See you next week. Have a safe trip."

"You have a good layover."

I wrestled the ancient doors closed as we started to pull, and the night air cut like a laser through the gaps in the doors.

There was a light layer of snow covering all the bags, making them into white-dusted shapes, and I had to be careful walking on the icy iron floor. I arranged the bags by destination and double-checked the piles for the morning baggage stops. Sometimes baggage men got careless and buried one, and then you had carried-by bags and complaints. Finally it was time to walk back through the train and meet the passengers.

The first car after the baggage car was called the coach dorm. It was half seats and half bunks, and we tried not to use it for passengers because it was where the on-board crew cleaned up and slept. But tonight it was full of sleeping travelers and the diner crew cleaning up and getting ready to hit the rack.

The on-board crews were like close families. Unlike us train and engine crews who had to get off the train after twelve hours, they stayed on board

from Seattle to L.A. and turned around the next morning and came back. Catching four hours sleep here and there, serving the passengers, cramped together in dorms or sleeping in seats, they got down and quirky with one another and kept a running conversation going for days.

"Hey now, here comes the real conductor lady; how you doin' tonight, babe?"

"Yeah, here's my fav-or-ite conductor. Ain't that right?"

"That's me. How's it going? How's the train been tonight?"

"You know, my favorite song. 'You must'a been born an asshole, 'cause you been one all your life.' All I got to do now is go check on my traps, you know. See if I catch a blonde or a brunette."

"Squeeze right by, girl, squeeze right by. I don't mind."

The sleeping cars were next to the baggage car on the head end where the high rollers paid $300 a night for accommodations—just to take the train. Their sleeping-car attendants were relaxing in the diner now, punchy and dishing the gossip.

"So I get this one older lady, man, she so helpless she trap herself naked in her room. I'm not kidding you, now, she really did this. See, she drop her glasses behind the bed. And you know it's tight back there. But instead of callin' me, or moving the bed, she reaches down there and grabs hold of 'em. But then, she can't get her hand out, you know, she trapped herself—all lookin' like this—over her own bed. And she naked, man. So she pulls the call button and I have to go in there and tell her, 'Ma'am, let go of them glasses.' And she don't want to let go, either. Now you ever heard anything as stupid as that?"

The diner was the middle car, and we installed ourselves there all night so we could control the train. The conductor's tickets were dumped on a table and the coffee pot was on. I started sorting out my sleeper pouch and testing the coffee. We had three hours to Dunsmuir, a tiny railroad town halfway down the Sacramento River canyon. Three hours to let the night roll by, count the tickets, and take the pulse of the train—the moods and problems of the passengers. It was 11:30 and we were about ready to close down the lounge and start putting the rowdies to bed.

Rich, the conductor, came walking through the lounge car and plopped down across from me. His silver hair was in a military cut, an attitude shared by his spit-polished shoes and sharply creased uniform.

"You know, Rich, I'll never look like you do in a million years. Two hours on the job and I'm pigpen. It's hopeless."

"It goes with the whole picture. You didn't get to have the Marine-sergeant father either." Rich waited a minute as the cloud of that story passed overhead. "By the way," he said, "You won't believe who we got on this train. It's your old buddy Warren. It seems he's lost his wallet again. So they wrote him out a seven-thirteen. Seems he wanted a sleeper this time, too."

I shook my head. Warren's ability to run a con was breathtaking. He was whatever you were, and he could intuit it in a second.

"Can you believe this guy?" I said. "The first time I met him he was sitting in a sleeper practically undressed. I think his glasses were even on crooked. No shirt. No belt. In his socks. I guess he wanted to look moved in. He told me he was a famous writer and could he write a check? I told him no checks but I'd fill out a seven-thirteen form, that it was his promise to pay."

"Yeah, I remember," Rich said. "And you know he even asked me how you get to Cleveland on the train. I mean, he's planning to ride to Cleveland after he gets off this train."

"We can't ignore him, either. He's not low-key. He's going to be a pain in the ass all night wandering around in his socks, mixing into things, perfecting his rap. Big-time journalist. With Kennedy in Dallas. Just send my secretary a bill. People just keep writing him out seven-thirteens and he just keeps riding."

"He even calls them seven-thirteens now."

"Well, at least he's not sticking some trainman with bad paper. I told him about the seven-thirteens."

"He's already mixing into things," the lounge attendant volunteered. "He's been with that group downstairs, complaining that they're selling drugs on the train and that it's a federal offense. Says there's a man high on cocaine who's capable of killing someone. The chief told him, 'Well, at least he paid for his ticket.' Didn't shut him up, though."

"Nothing shuts Warren up, if I recall. Say, was he drinking?"

"Sure was drinking."

"Well, that's another lie. He told me he quit. I thought that might be why he was so messed up, why he lost his I.D. and couldn't keep his shoes on.

But then, he's such a chameleon. As if he knew that I'd quit drinking and I'd fall for that one."

"That's amazing," said Rich. "You know he told me he'd relapsed, which come to think of it was right on the money, too."

Rich had been sober about as long as I had, but lately he'd been chipping. It started when the new fireman came on our crew and started inviting everyone to the sports bar after work. He was a big, handsome ex-football star from Cal and he made drinking look good. Rich was married and didn't cheat, and so the layovers away from home got cold and friendless, the way they were for me. I wasn't saying anything. I knew how useless it was.

"Right," Rich said, turning to the tickets, "Another night on the crime train." He turned to the lounge attendant. "Hit the rack, Pete—we'll mind the store. You want a wake-up before Marysville?"

"Yes, boss. I'll be in A. Give me about twenty minutes. You folks have a good night."

"Oh yeah, all the time."

We spread out our tickets and settled in with the rock and shake of the train, hitting the joints at a regular forty-five and the smooth specter of Mount Shasta floating closer in the moonlight. We went in the hole for an eastbound and hit some color on the mountain, so we lost some running time and were late getting into Dunsmuir. I was upstairs in the coach seats trying to load some passengers without waking up the whole car. People tend to absorb all the available space at night, and you have to wake them up and move them to make room for the late-night boarders. The lounge crowd was still partying, getting booze somewhere, and they kept stumbling through the coaches, shouting.

I had a couple with a baby I was trying to find a seat for in the dark when two guys were at my elbow muttering something about cocaine. They were in T-shirts and had drinks in their hands. A huge man in a cowboy hat was with them.

"I need to talk to a conductor right now. I been ripped off and it just ain't fair."

"Sir, I'm helping these people right now. I'll talk to you in the lounge after I do this. Same goes for you guys."

"Hey, I resent—"

"Case closed. In the lounge."

I got the family some pillows and the car started to settle down, just a few hacks and wheezes from the smoking section, the Starlight doing the old rock 'em to sleep, when another agitated voice appeared from the lounge.

"Conductor, I need a conductor. They're fighting in there. They're hitting each other."

Downstairs, the two men in T-shirts had their arms wrapped around the cowboy's windpipe, his eyes wild and pinpointing. I touched the shoulder of the guy on top.

"OK, back off, get off him."

"You want me to get off him? He tried to kill us."

The man's eyes were out of focus. I put my hand on his shoulder, gently, like I would touch a lover. I felt the heat of his body beneath the cloth, and a slackness of muscle tone. His arm felt soft to me and I understood some other softness about the man. The black eyes swam around and found mine.

"Cool out, man. Cool out."

The eyes were there with my eyes. I felt the energy sinking into my body and I let it go in there, join mine, be peaceful.

"Yeah, it's O.K. Get off him."

Rich was downstairs by now, and herded the other fighters off by themselves. I was left with my hand on the cowboy, us both breathing deeply, like a wave had gone over our heads and missed us this time.

"What did I do?" No violence tagged on the voice—fear—but he trusted me. I let go of his arm.

"I don't know, man. I don't know."

The energy was shaking me a bit now, so I sat down opposite him and we both stared at each other in relief. The bad parabola had gone. The storm was elsewhere for a while.

"I know I'm an addict—I'm going to the V.A., but I got in some trouble up north, two drunk drivings, cost me a thousand dollars and a night in jail. But I can fix that—I got two hundred Christmas trees to sell in Wasco. That's where I'm headed now. I just got out of jail, and I knew I shouldn't have a drink, but I did, but they just shouldn't take advantage of a man like that, it ain't fair. I know I'm addicted, I admit it. I got that way in Korea. And here, this gal on your train, she took me in the bathroom and gave me a taste. I said, "Fine, how about a twenty-dollar bag," and she says, "That's all you get for twenty." I mean, I know what's happening. "That's all you

get?" So I object, but then she had two guys with her that I didn't know about, and I'm an addict, I admit it, but that shit ain't fair, it just ain't fair."

I decided to tell him the truth. "No, but it's going to keep happening."

"What'd you say? How do you know that?"

"I just know it."

He shifted gears in his mind, like a large, industrial machine. Something rolled over the top, and dropped into another emotion. Tears started to come into his voice.

"I'm just so damn scared. I'm scared."

Rich came back downstairs, checking the level. All being cooled down, he sat down with me and J.D., the cowboy, and we all took a break.

"What's going to happen, man? Wha'dya you say we just forget it. Just forget everything and everything'll be fine. We're not going to do anything, are we, man?"

"No," Rich said carefully, "I don't think we're going to do anything."

The train rocked and creaked and I felt the adrenaline rush turn clammy and melt into fatigue. I wasn't really talking to the cowboy anymore, just going through the motions. Him telling me how he was going to fix things, how he was glad I was there.

"Hey, man, this here's a real nice lady, here. I mean, I'm really enjoying talkin' to y'all. I'm an addict, man, and you just don't know what this shit is like."

"Oh, I think I do know what you're talking about." Rich looked down at his spit-polished shoes and then at the late-night wreckage of the lounge. He stood up to leave. "I'll be in the diner," he said, giving me the look. "Writing."

As I sat there, a memory was starting to push up. I knew it as living in my lungs, in the times I had trouble breathing. Going hand-over-hand along the side of a pool, I remember the large white number 6, large to a small child, the portal of the deep end, and I remember letting go and going down, water filling my nose, breathing water, choking, the hot panic of water riddled with light, seeing the light through the water above me. A pair of strong arms came down and pulled me out and put me into the arms of my mother, whom I hated blindly for this, for this happening to me. My first loss of her, my first letting go, inexplicably, of the handholds, of the railings of the world.

"I don't know what to do about it. I'm scared." The cowboy's voice floated over the image.

"Give up. And ask for help, J.D."

"Ask for help? Are you kidding? They kill you if you ask for help. They kill you."

"What are they doing now, man. Aren't they killing you now?"

And the strong arms of the lifeguard reached down for me, and I felt betrayed. It wasn't her who rescued me. And here I was sitting with J.D., who knew that they kill you if you ask for help, and yet it was going to be O.K. for the rest of the night until the cops came to take him off in Redding. Rich was making the arrangements. And even then, J.D. would go quietly and look back and say, "Hey, thank you, man. I really enjoyed the conversation."

## The Modern Railroad

I left home, driving five hundred miles down the Central Valley to L.A., following directions to the execu-condos in Seal Beach the railroad had us in for our twenty days a month working. I put new air conditioning in my truck after driving home in July with a wet towel over my head all the way. Now it's September and I'm on the L.A. brakeman's board, but in reality I'll be catching conductor-only runs to Bakersfield or Colton most of the time.

The conductor-only crews are just an engineer and a conductor with a radio—no caboose, no one to help with the switching, and, in a lot of places, no clerks to check the trains or the lists, just an empty room where you and the engineer meet at two in the morning with a computer and a printer that spits out a list of your train. Frequently, when the train does arrive and you and the engineer get on the engines, the first cars in the train bear no relation to those on your list and you wonder if they are just reversed or if there was an unreported pickup and your tonnage is wrong. That happened to a crew in Bakersfield who got on their train and took it over Cajon Pass only to find it was heavier than they thought it was. They pointed out the spot to me where it left the tracks at 120 miles per hour and cleared out a housing tract, killing all the crew.

Of course, you could walk the train yourself, like the clerks used to do and the conductor used to do when there was a caboose at the end of the

train to ride, but that would take an extra hour and you can't move freight on the main line if you do that, so you just get on the engines and ride.

In L.A. and Colton they still have clerks and yardmasters around who give you good lists of your train, so your only problems are getting the dispatcher to let you go anywhere. Since they moved the dispatchers to Denver and doubled their workloads, it's been hard to get them on the radio and harder to explain what you want to do. They have to know the territory well to understand what your move requires in the way of signals so that it isn't just an abstraction to them. You can tell in their voices if it is, because they talk to you like you were in line at the D.M.V. or trying to dispute your phone bill instead of trying to maneuver parts of a 9,000-foot train into an industry track that abuts on a main line controlled by their absolute signals, which they have to give you every time before you can move.

Working involves mainly waiting for these signals, often for hours, so that you can complete a delivery that could have taken twenty minutes if you had the dispatcher's cooperation—with the shipper wondering why his boxcar is sitting on the main line outside his warehouse when he needs to unload it immediately. The conductor on a local hears from shippers every day and gets the feeling he is swimming in a kelp bed of obstacles placed there by the company that is telling him to get the work done. Some railroaders assume it's a plot by the railroad to sabotage itself. Others personalize it—blaming the ill will of dispatchers or rivalry between the terminals.

"Colton never talks to L.A. about what they got coming. They just want to get the trains out of the yard. Never mind they sit for three days five miles out 'cause there ain't room for them—just get them out of the yard. Soon, though, trains can't run 'cause there ain't no more room on the sidings for a meet. Then they just rehump everything in the bowl to keep the car count up."

I prefer to think of it as a system functioning automatically without a brain, like DNA or government in general. I prefer a world of accident to intentional malevolence or God's unknowable plan.

"Did they give you your tuning fork yet?" a fellow conductor asked me.

"Tuning fork?"

"Yeah, for calling the dispatcher on the radio. You just hit the fork and hold it up to the old radios and it sends the frequency for the dispatcher's call button."

You had to use the call button on the radio's PBX when the dispatchers wouldn't answer normal calls over the radio. The new engines had a new frequency, so if you were on an old one, you now had to use a tuning fork to call them. Railroaders were beginning to wear them around their necks on chains as a new form of jewelry. The dispatchers stayed a step ahead of us, however, by using voice mail on their PBX lines. Then the only thing you could do was to get off the engine and find a phone booth and call them on the regular phone line.

"What if we hit somebody, for God's sake? Am I supposed to leave a message?"

"Oh, they won't let them smoke in the building, so they have to go outside for cigarette breaks."

"Pretty soon they'll be keeping timekeeper's hours, which are better than banker's hours."

"Not like our hours, that's for sure."

Ours were still close to fourteen hours a day, figuring in the time it took to drive from the execu-condos to the yard office to catch the trains. The Feds cracked down on the railroad for letting us sit on the trains after our twelve-hour time limit was up, so now we are supposed to be in a taxi heading back to our terminal by twelve hours, but the trip back can take however long it takes. We are still only entitled to ten hours' rest after we get in, and that, minus the time it takes to commute, shower, and eat, can add up to less than eight hours' sleep between runs. Sleep deprivation is still the most dangerous factor in railroading, and one that gets no attention from either the press or the federal accident investigators. The F.R.A. wants to spend millions of dollars testing for marijuana use; meanwhile, the crews running main-line trains through city neighborhoods haven't had eight hours' sleep at one time in a month.

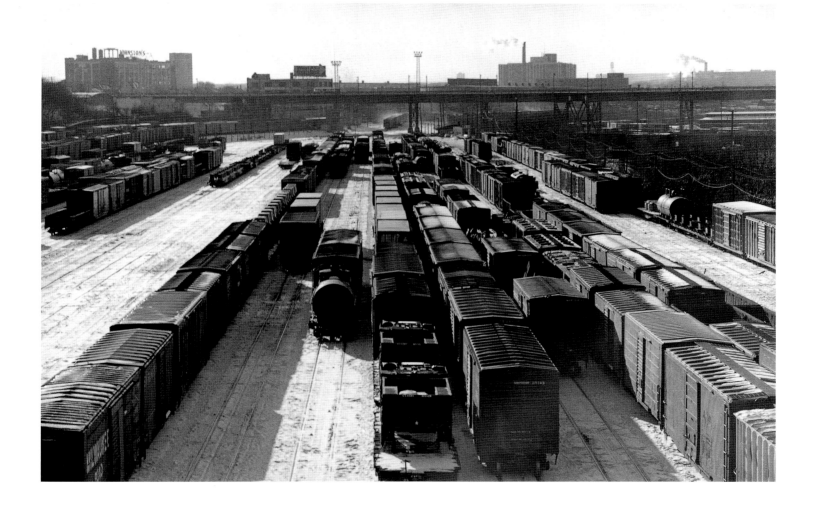

hump yard

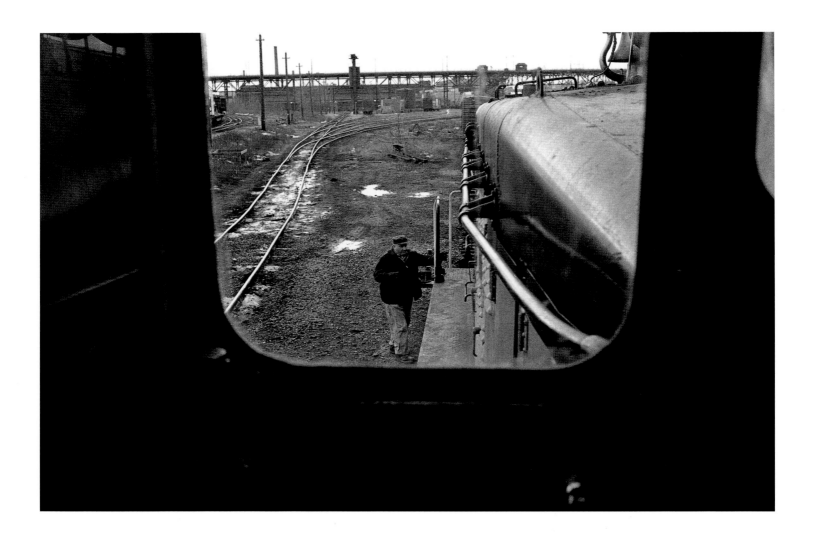

from the engine

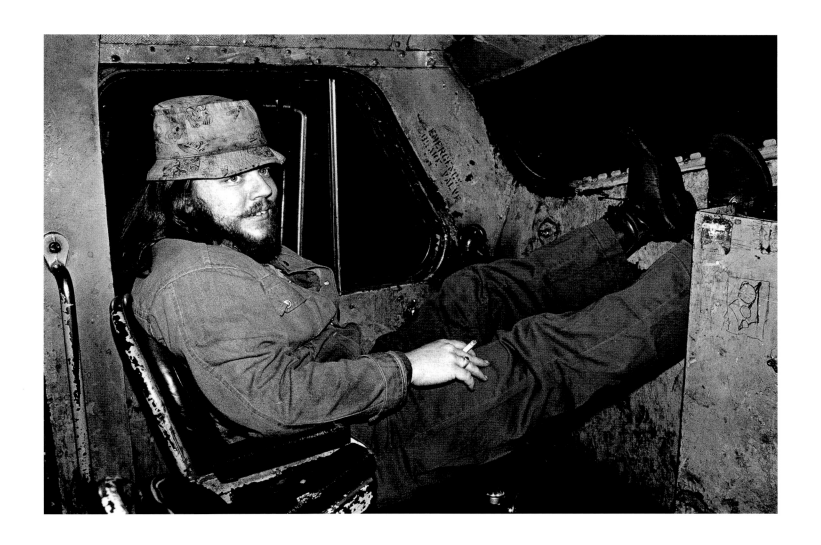

inside a switch engine

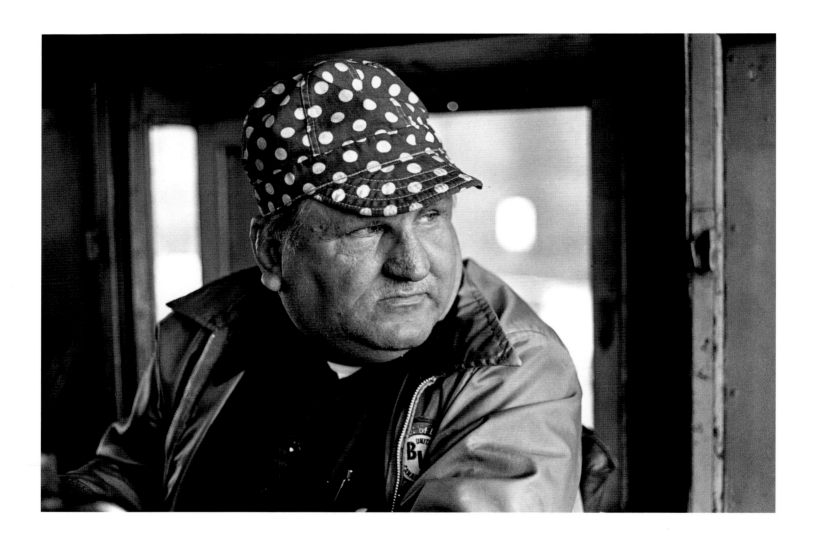

engineer's cap

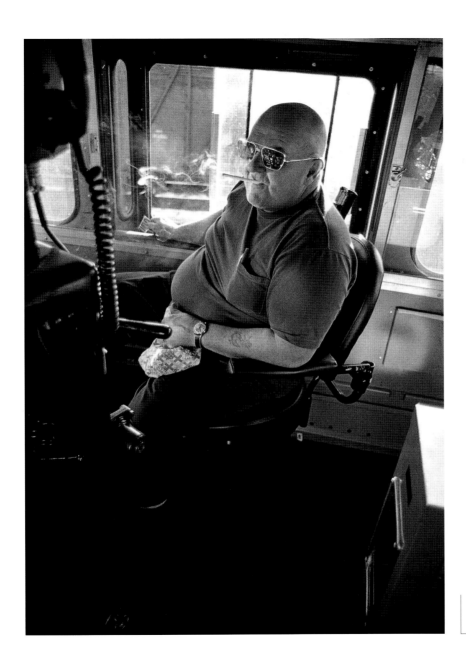

engineer, sunglasses, and tattoo

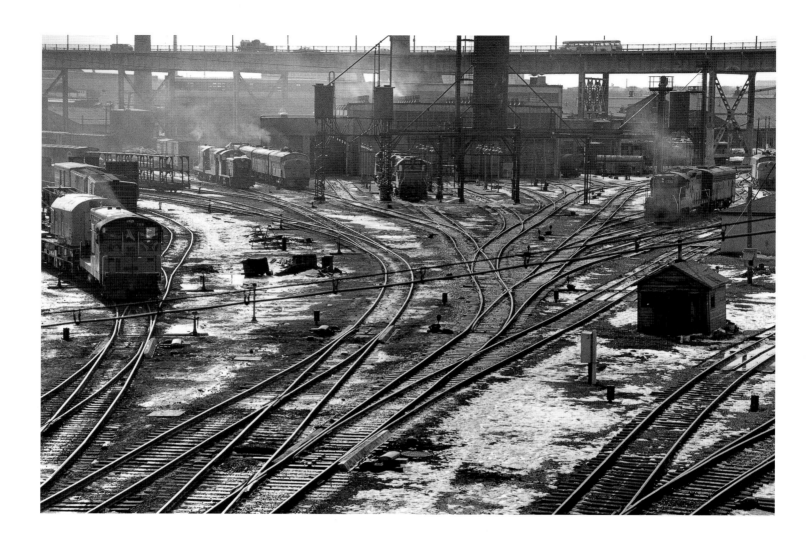

diesel engines at the roundhouse

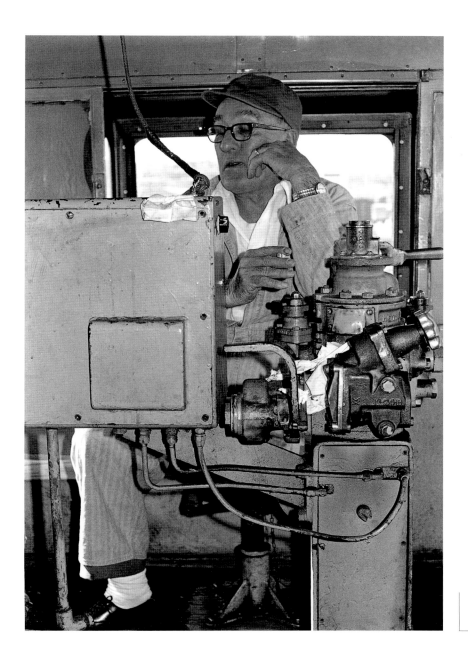

inside a switch engine

on the overpass

tell tales

## Conductor Only

Called for a conductor-only run from Colton to Anaheim, never worked the territory before, no place to yard the train, itself sitting on a siding for three days before we climbed aboard, still no place to put it away, we spend the day waiting for red signals to make a series of small advances, and now, after midnight, I stash seventy cars on the Long Siding, drop off the engine and count the cars rolling past me, checking my list. I stop the engineer at seventy, cut off the rest of my train on the main line and ride the last boxcar up to the siding switch under the freeway bridge, where I use my new L.A. switch key on the giant locks that vandals can't cut through to sabotage the trains. They take lots longer to open, though, and I smell the doused embers of a campfire, acrid wood close by, and I am aware of my back between my shoulder blades and the cardboard shack someone has constructed up under the bridge whose pilings are marked with graffiti, the ground beside me littered with old spray cans and dead tennis shoes. I always wonder, when I see stray shoes, what happened to the people wearing them, remembering engineer Mike Sarratt telling me one time he stopped a hobo in Salinas from bashing a sleeping drunk for his boots. And then I think once again, should I be carrying a gun? and hope I get away from L.A. before I find myself at a survivalist store buying one. I walk down the track and close the derail, way

too nervous now, mainly because I don't even know where I am, what streets these are, who lives on them, and I use my radio to tell the engineer, a good half a mile away, to back them up, and don't really feel good until I see the engine and I have the brakes tied and am on it.

## Women in the Yards

"I think they were afraid we were going to clean it up," Mary Alsip told me. "You know, like it was their clubhouse, and we were going to sweep it out."

If a man were to enter a totally female place—a holiday kitchen, the crowd in front of Filene's basement in Boston, or backstage in a strippers' dressing room, he would be surrounded and incorporated. Women would neutralize him by teasing or joking. They would invite him to become lighter and younger, so that the gossip could continue as if he were a child again, listening on the kitchen floor.

I try to imagine pornography in such places, *Playgirl* centerfolds, bragging, standard jokes, safe topics—a speech code that everyone adheres to or else keeps silent. It seems impossible. A women's circle is filled with anarchic energy, overflowing emotions, truth telling of every detail of our lives, even if it reveals our failings, much talk about sex, the sharing of fears and personal wishes.

In the shanties of the men's world, women felt like alien invaders, sitting across from centerfolds of spread genitals, confronted by overflowing trash cans, litter, and misspelled graffiti. It seemed as though men rarely talked at all, and if they did, it was never about themselves, about things they really cared about.

It wasn't that we were keeping them from gossiping about women. They rarely did that anyway. We were there on the lockers in a silent airbrushed presence that was seldom even acknowledged.

It was their ideas about our civilizing natures that had to be short-circuited to allow them to be comfortable with us there. And so it was a matter of time until they became so used to seeing us and so reassured that we would tolerate the mess that they could finally relax and go on with their fishing and vacation stories, their fixer-upper stories, their jokes on each other that made up the background conversation to spending most of their lives safely in each other's company.

"I walk into this shanty and, of course, I don't know where to look because everywhere I look there's a vagina and a breast. I don't want to look down, but if I look up all I see are wall-to-wall naked ladies and spreads and the whole thing. And nobody would talk to me. It was just embarrassing. Somebody's talking to me and right behind their face is this vagina that's opened really wide and you can see everything or some woman making these slinky poses with these enormous breasts hanging out. It was kind of strange.

"But then after about four days of being there, they just started being really nice to me—it's like they were accepting me being there. And then I just got to be friends with them and I liked them and they liked me and all that.

"One time I went down to Warm Springs on a seven-day stand and I went into the shanty and sat down, and, of course, no one told me that I was in Old Joe's seat and that he's been sitting there for thirty years. They just sat there and it was all dead quiet, and I knew something was wrong but I didn't quite know what it was because it's pretty typical—they do that a lot, you know. There's always dead silence. Then it takes a while before Old Joe walks in there and he won't say anything either; he just stands there and stares at you and then he starts making comments as if you weren't there.

"When I started my real trips on the road, the conductor said, 'O.K., I'm going to drop you off here and you're going to roll the train by and catch the caboose.' And so I said, 'O.K.' And then he left. I was thinking, 'Oh my God! What is rolling the train by?' I had no idea what he meant by 'rolling the train by.' It was my first official duty and I was standing there thinking, 'I know I'm supposed to be doing something,' but I didn't know what. And, of course, I wanted to do the right thing. Then this old switchman that I had

worked with on my first student trips—Johnny was his name, he was just a real sweetheart—he comes out there and I said, 'What does it mean to roll the train by?' And he says, 'You're doing it.' 'I am?' He says, 'You just stand here and look at the train.' I thought, 'Oh, whew, I can do that.' You know, that was funny."

*Pat Doolette, Southern Pacific conductor*

"There were the graffiti notes such as 'Angelos went down on me here,' and when Karina, Lina's sister, started working on the railroad, the first time she went into the shanty and saw this, she was upset. And so she whittled onto it, 'My auntie did not do any of this stuff.' In the same shanty some-one had written 'Railroad cunts go home,' and we were going to take a shot of that and that was going to be the name of our book.

"Karina and I got called on a job together and we knew we were going to be working in a shanty that was covered wall-to-wall with pornography. We had been saving up *Playgirl* magazines for a time when we would be working together, and we brought the magazines, scotch tape, and glue. We completely plastered the whole thing with *Playgirl* pictures and drove them nuts. The frontal pictures were down in a day or two. The rear pictures stayed up—they weren't as offensive. The frontals came down immediately. At Union Station, after I started with that one *Playgirl* picture, I attached one to my locker and when I wanted to create a stir—when someone was hassling me or something—I'd hang another picture. I'd stand in front of the picture, put my hands on my hips, and start making noises—ummm, *ummm*. Especially when I got a picture of a black male—that would piss them off. That created the biggest stir. I was not to do that. I enjoyed doing stuff like that. Once I realized I had as much power to affect them as they had to affect me, then it was a game."

*Cindy Angelos, Milwaukee Road conductor*

## Night Time

"It wasn't 'til I had about five years with the railroad that I realized that they ran trains in the daytime."

*Mary Alsip, Southern Pacific conductor*

When they sent us region-system brakemen to the Roseville yard, it was in February and cold and raining. We came behind all the regular men on the extra board, and so our first shifts were all midnights and usually we were all called together to be foreman and helpers. Most of us had never worked the yard before—all six miles of it, from hump to bowl to East End flat switching to main lines running in and out of the yard north to Dunsmuir and east over the Sierras to Sparks. There were six of us from Watsonville staying at the company motel, an establishment whose idea of luxury was an extra television in the bathroom. Each night they would call an entire inexperienced crew to stumble around in the rain all night, trying to find out where the tracks were.

They had just taken off the subway herder job for the middle of the yard, so that now main-line trains were lining themselves through the yard at the same time that switching moves were being made by both the east end and bowl jobs—which, incidentally, were all on different radio channels. It was

unsafe enough for the old heads in the yard who had been working there for twenty years, but with everybody out there from somewhere else, what the switchmen call a "jackpot" was bound to occur.

Around three in the morning, our crew was pulling out a rail full of cars to couple it to another bowl track. We needed somewhere to back into with our cars and used a running track as our tail that main-line trains also used. We backed up fifty cars into that track, then shoved forward twenty cars, and we were backing up again when I noticed that the train on the track next to us was moving—onto our tail track. The yardmaster had given it permission on another radio frequency, and it had taken our lineup away and was on the move. We managed to get stopped about six inches from their engine.

At the same time, at the hump end of the yard a car had gotten going too fast down the hill and was rolling out of the bowl tracks toward the cut of cars we had shoved in. The hump job's field man had to run it down to tie a brake on it—thereby violating the company's new rule against getting on moving equipment.

Simultaneously, at the east end of the yard another Watsonville switchman had just kicked a boxcar by mistake into a clear alley—a track with no cars on it. The yard was on an incline at that spot and the boxcar came roaring down the alley and derailed a switch engine sitting on the bottom end of it and knocked the hoghead off his chair.

We all met in the trainmaster's office for a short break in the action to discuss safety. It was the first time we had met him and we found out later that he was new there, too.

# Jumper

All-nighter in progress, the Mission Bay local, a pickup drag around San Francisco Bay. It's the first of May, an extra crew—except the foreman—all young for a change, lighthearted, working and talking into an easy groove. I've worked with Bill Sheehy, the field man, before in Utah, Tucson, New Mexico, and Texas, as boomers following the work.

We switch the engines out in San Jose, leave our train on two rail. I'm the head brakeman, discover at the switch I've lost my keys. It's unlike me; my life must be changing. I must be falling in love.

Bill makes the long joint as we're shoving the boxcars in, lines the switches up the lead, lends me his keys.

"You grab the ones to your handcuffs instead?"

Taking the engines to the house, I borrow more keys from a sleepy round-house man.

"You better bring these back. I have to sign."

The action wakes me with an adrenaline stab, and I close my eyes on the engine as it rocks around the curves, and I have no defenses against thinking of you, wanting to turn over in the night and move against you. I'm not calling the signals now, the thoughts are too sweet, it's too late.

"Got a yellow."

"Yellow in the yard, restricted speed."

Fuck me honey. Fuck me.

Our pickup is in Warm Springs, 4:30 and beginning to hover light. We can't make a difficult joint. The drawbars won't line up; one side needs lifting. The conductor finally walks up from the caboose, shakes his head, finds two railroad spikes.

"Give me some strong backs, boys. Lift this knuckle up; you put the spikes under the drawbar, O.K.?"

I slide my fingers under the lifted steel, put the spikes in place to raise the coupler an inch or two.

"O.K., back 'em up," and the two coupler hands drop into line. Old head slick. Bill and I, ten-year brakemen, sheepishly grin.

"That's what they pay him for, I guess."

Six-thirty into San Jose, we set out half our train, and I take the engines down Five rail to tie on and go, rocking down five rail, a refreshing bath of light now, commuters on the platform, the morning food truck. Should I drive to Berkeley and find you? Just open the door and find you in your bed? Fall into you?

All kinds of radio commotion. The bad news is another suicide on train 25. "She threw herself under the wheels."

We'll be stuck for hours, officials crawling around, commuters gawking.

"They say they all could hear it hit."

"The coroner don't go to work 'til eight."

The engineer starts telling his stories. He is the executioner in his dreams.

Things he has hit on the train: a charging bull at Sudden, a hay truck, an outhouse, shopping carts, sofas, a Christmas tree, bicycles to go under it, snowmen, a tree, a washing machine, buckets of spikes, garbage cans, TV sets, water heaters, freezers. A swan diver at Santa Barbara (gave him a nine), someone who appeared to be swimming between the rails, a sleeper who jumped away in time and flipped him the bird. Hundreds of sheep eyes on the curve at Seranno pulling sixty empty beet racks at 3:00 in the morning. But he shut off the headlight and herded them back in their gate.

We go to eat now; our carryall driver's been here since 5:00.

"Didn't see anything bigger than a foot long. An older woman, judging by her hand."

I order a number two, hotcakes and an egg over easy.

"They said it got all over the cab. It's the brakeman's job to identify the body."

"No, it's the conductor's job."

"No, it's the brakeman's job."

We get a highball to leave the yard around a quarter to 10:00. I space out, don't notice the spot, the engineer pointing out the pieces. I'm still wanting you, feeling you touch me. "An older woman, judging by her hand." "She sat up and smiled at the train."

It's hard to pay attention now, my body wanting sleep, wanting to fall into fantasy. The engineer is talking about spotting the jumpers, how they hang around bushes, the looks in their eyes.

We pass San Carlos. Beside the tracks—a Mexican cross, hung with plastic flowers, marking the spot. There are so many of those throughout the Southwest. Could so many have died from trains and drunkenness? Were they sleeping on the tracks like summer rattlesnakes?

Too late to wake you now, I drive down the coast, numb from no sleep, the freshness of the day pouring over me like water I cannot feel refreshed by, wasted on me and on her, an older woman. I go to bed and sleep for the afternoon. At 7:00, when it's cool, in the shower I cover my body with scented soap, thinking of your soft hands and of the fact that it is still somehow today.

night skate job

carman's locker room

yardman's locker

yard conductor with switch list and butterflies

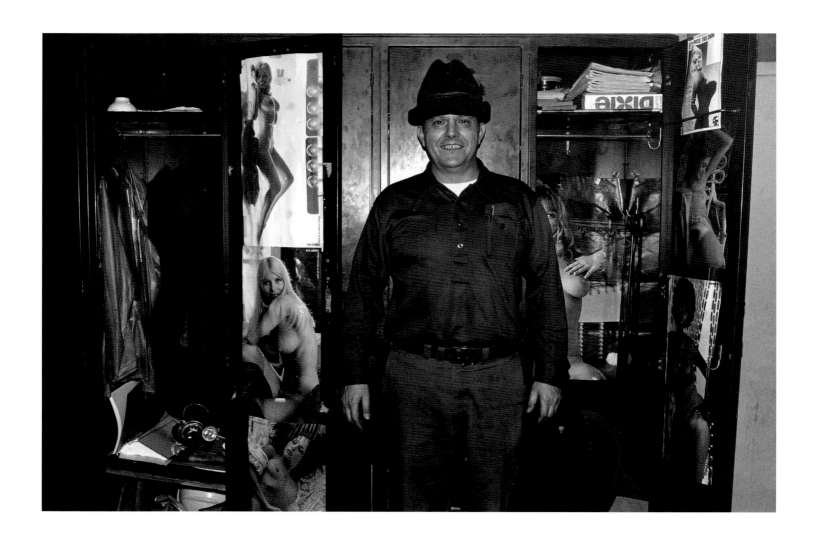

with the girls

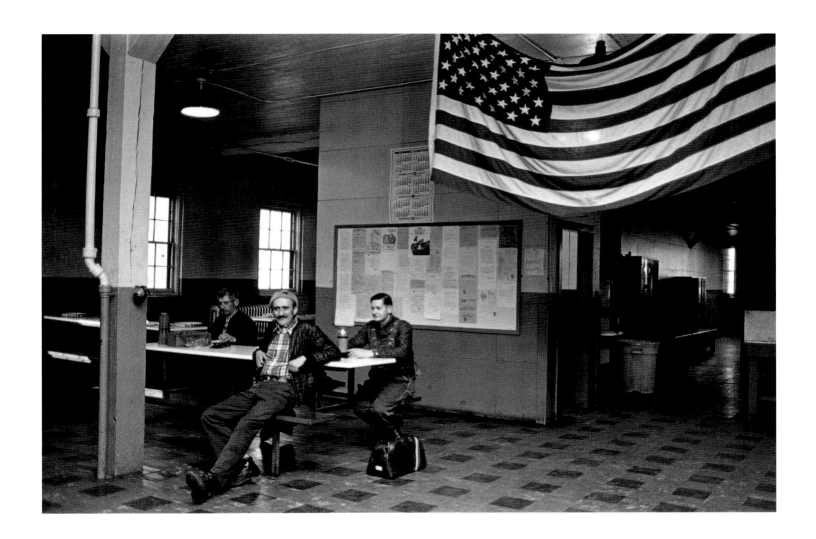

on spot at Schlitz

## Killing the Switchman

Her name should have been Breathless. It was Betty, but there was something breathless about her, some asthmatic contagion, along with the attraction, that struck like a panic attack once she was out of sight, even for minutes. As if the solid streets of San Francisco would begin to melt like a baked Alaska, as if north to Mendocino now meant south to San Jose, as if once I hung up the phone, all traces of the conversation now fell into the big disposal with the metal teeth, and not the softer one that only eats socks and washes clothes and gently reminds us that after a certain time we will fray and fade and be nothing.

This feeling should have warned me, but I still thought love could make you immune. Food and sleep seemed unnecessary. The forces of nature spoke for us, frantically filling in the trust-gaps usually supported by language. Betty certainly had an impressive metonymous range.

That's why the storm bothered me so much, coming after we hung up. I mistook it for a mood swing, imagined it was trying to huddle us together under its windy wing. Personification, also, had set in.

Whatever it signified, it had been a big one. I had to take a railroad rules recertification exam in Oakland the next day, and the Port of Oakland was showing whitecaps and the normally deserted industrial streets were full of parts of trees. Normally, I study for these tests, if only to gratify my ego. Tak-

ing tests is the only thing I can do better than most of the men I work with. Today, however, all I could think of was seeing Betty, as if she were the proverbial tree falling in the forest and I was the lone listener.

"How many times, Linda, have you taken this conductor's rules test?"

"Oh, in ten years, about twenty times, maybe thirty times."

"So you ought to know, then, that red flags have to be respected on either side of the main line." Tom, the flirtatious trainmaster, was trying hard to be authoritarian.

"Read the rule. It says, 'They belong on the right.' It's ambiguous. Besides, we always stick them on the right. Oh, I know, I'm not concentrating. I passed, didn't I?"

"Barely. Maybe if you had taken more time."

"So I passed, so I'm outta here."

I hit the freeway, radio on, a panicked desire buzzing in my ears. All objects were flying like static charges. All the debris of the city was airborne. The quantity of it was amazing. It was like being leafleted by your own garbage. A past attack. I had six hours until I had to be on my train, highballing five hundred miles toward Oregon, keeping watch over the sleeping passengers. I didn't feel like it today. I wanted just to be inside. To watch Betty do something reassuringly routine, like plumping up the fabric-covered pillows she nested on her wicker chair, folding her comforter in three folds and draping it over the chair back, turning back the 100 percent cotton corners of her bed. I wanted a light on against the wind and her skin warming on my skin.

It either would be that way or everything would go wrong. I felt, though, that the storm was on my side. Even big cats get out of the rain. Betty's wind chimes were banging for their lives and dead night-blooming jasmine vines littered the flimsy walkway to her door. There was a light inside and her hair was wet and smelling of soap when she answered the bell. I knew her body would be warm and moist under her robe.

"I wanted you here last night," she said. "I wanted you with me in my bed."

We slept all tangled up together until a thin line of red appeared between the water of the bay and the dark waters above it. Betty got out of the bed to make me dinner, and I lay there, gathering the part of me together that would take me out the door and into the aluminum shell bound for Seattle

out of L.A., due into Oakland at 8:25. My life was being lived along transportation corridors—freeways, Seven-Elevens, telephone booths, gas stations, motels, railroad routes, change rooms, lockers, answering machines when I get home, beepers, and phone calls in the middle of the night asking me to go to work.

She had set the table with a candle and blue-and-white Mexican bowls. A long-simmered soup steamed out of them. She poured a glass of chardonnay for herself and Perrier for me. I reached down and plugged in the string of colored lights that framed her window beside us. The moment closed around us like a friendly fog and the sky opened briefly to show off the fading light.

"Some times are like this," she said. "Perfect."

I kissed her at her door and let the wind take me down the wooden stairs, out the unruly gate and through the littered streets again. The depot parking lot was strangely empty. The fireman on the job, a big ex-tackle for Cal, met me in the change room.

"You too?" he said. "I guess you weren't by your phone. The train's ten hours late. A derailment in Oxnard and our train is on the other side of it. They're sending number twelve back up here once a rested crew gets to them. It'll be tomorrow morning for sure. If they didn't call you, you stay on pay. Want to go somewhere for a drink, or did you eat already?"

I made an excuse and found the pay phone to call Betty, although I had a premonition that it wasn't a good idea. Repetition in her case was not possible.

"Betty the train's late. Not 'til tomorrow. Are you sure it's O.K.?"

I hung up the phone and joined the knot of trainmen by the snack bar. They got quiet when I walked up and I had to ask what was going on. Bill, our union griever, told me in a low voice, "The crew on 709 hit someone in the Bakersfield yard. It was bad. One man died, the other lost his legs."

"Who were they?" I asked, thinking passengers, thinking the knot of people and suitcases and children swarming around the train. How could they have moved over them? Wasn't there someone on the point? Or was it a bum in the yard, appearing out of nowhere, too late to pull the air? I went through my list of possible nightmares. The rear man, giving a backup from the diner. Not being at the door. Not watching. For that was my job. I hadn't always done it right. Chaos could have come under the door.

"They were switchmen," Bill said. "Santa Fe. Old heads, too. They should have known. They came off their engine and walked right in front of the train. Nothing the rear man could do."

"He wasn't watching," I thought. "He could have stopped the train with the emergency valve. Why wasn't he watching? Wasn't the door open?" My mind wouldn't stop on this one. It was scrambling for a reason, something the man could have done and didn't.

"The whole crew is out of service. Trainmaster flew down there tonight. They're waiting to hear about the other guy. If he makes it or not."

The anger I felt was a fear that lived in my physical body, in the habits of caution built into my life as a freight brakeman. It showed itself in exaggerated reflexes—the apprehension that one day an inadvertent move of mine would take someone's life, an inattention to the peripheral picture in which a human body was between steel wheels somewhere connected to me, to the signals I gave, to the job that had become routine and mindless. And that it was luck, or grace, and not under my control always that this wouldn't happen to me.

I had thought I was safe from this on a passenger train.

I could see Betty lying on her sofa through the windows. There was a glass of red wine on the table beside her and I felt like I was intruding. I lay down with her on her oriental sofa, feeling her reluctantly make room. Some revision of the love story had occurred.

"When do you have to be ready in the morning?" she said briskly. "I was going to take a bath. We could do that together."

There was a map of the world on her shower curtain. She had been in Central America as a nurse in the Peace Corps, and I eased my body, with hers, into the warm water at the bottom of that world.

Although I could feel that I wasn't really welcome anymore, I started talking anyway. I suppose I wanted her to reassure me.

"We killed a switchman today and cut another man's legs off. The brakeman should have been at the door watching. It could have been me there."

The tone of her voice told me to stop. "Wait a minute," she said. "You don't really know any of this. You're jumping to conclusions. This is my area of expertise. I deal with this all the time with patients. It's just like post-traumatic stress. You don't have enough information. You're making things up."

"But it's my job. It so easily could have been me. It was the brakeman's fault."

"When they killed the priests, we knew what kind of atrocities were going to follow," she said. "They locked the villagers inside the church at Todos Santos. They spent the night thinking it would be set on fire and listening to their friends screaming outside. In the morning, the army was gone." The two switchmen were pale branches in the dead forest she wandered in.

Staying the night, I tried to take up psychic space in the bed to counter the body lying next to me. The closeness of the afternoon had fallen through a hole in the story of the day. I knew that my idea of the safety of the train was like my idea of love—that I counted on things staying pretty much the same even though I knew they wouldn't. But for her, the system had broken down, and she knew what to do to survive. And what my body knew was that I needed to prepare somehow for the day it was my legs across the rail and nothing more continuous than chance protected me.

## The Love Boat

I'd been watching "the action," as the trainmen called it, for over a year now, but I heard about it my first day, sitting in the diner with the On-Board Chief.

"I'll tell you something," he said, looking at me while he was talking to the conductor. "You better watch yourself out here. They got Pinks riding these trains and you would never know it from looking at them. Prime," he said meaningfully. "Real prime. And they will go all the way"—I could feel his beady eyeballs searching mine—"before they pop you."

Lesbian Pinks? I wondered idly. Could he be warning me? No, probably not.

"Now take Ron, the train attendant," the Chief went on. "Had a broad come on to him and offer him some smoke, so they get into it in the toilet and he told me, 'Chief, she went all the way. All—the—way.'"

Well, that was the first day, and I thought, "Oh, cock talk," about what you'd expect from some culturally deprived conductors who like to go sniffing out couples under blankets and checking the stairwells out after the lounge car shut down—nothing but the usual bullshit. But, no, there really was an epidemic of horny women who'd take on anyone in a conductor's uniform or anyone they met in the lounge car. The Pinkerton story was just

an urban myth. They would need a crew of Pinkertons playing one-on-one defense to keep these women in their seats.

"It's a goddamn Love Boat back there," the engineer complained as we got in the taxi after our run. The engines weren't connected to the rest of the train by a walkway, so all the engine crew got was soup and crackers.

He'd been skeptical, too, until the conductor offered to prove his point with a deadheading hoghead riding between Oakland and K Falls.

"I'll bet you I can fix him up before we hit Sacramento," he told the engineer in Oakland.

"This I gotta see," the engineer said, gulping down coffee for his twelve-hour pull up the Siskiyous.

Sure enough, in his rearview mirror at K Falls, he saw the hoghead emerge from the sleeper car with a beautiful woman on his arm. They strolled off together into the dawn.

"How'd you do that?" he asked the conductor.

"Well, you can just tell who they are when you're taking tickets. And you come back and stand by their seat. Pretty soon they're telling you what they want, and I just said I had this sleeper but a buddy of mine was in it already, a real nice fella, and I guess she figured that would be better than trying to sleep sitting up in her chair."

Boarding the Starlight one evening we noticed the disembarking conductor in a clinch with a female passenger. As he passed us on the platform he gave Sunny, the rear brakeman, the nod. In Klamath Falls, Sunny and the lady took their own taxi to our motel, and in the morning she boarded the northbound, no doubt making another conductor's run a little more interesting.

It took me a while to get curious, but finally I needed to know. "Why," I asked Sunny, "Do you think these women come on so much?" He looked angelically thoughtful.

"It's the motion of the train," he said.

I went into the diner. We close it off late at night and sit there to keep drunks from wandering into the sleepers and waking people up. Cadillac, the conductor, was busy writing his "Dear Jane" letter of the week. "You know," he said. "I could have laid that beautiful redhead that was in here before, but there was something funny about her. She knew too much about the railroad. She might have been a Pink. Besides, I started thinking, what would it amount to? Just another meaningless sexual encounter."

Cadillac was a tomcat, but we all liked having him for our conductor. He was six-four and built like a prize-fighter. This was illusory, since he was incredibly accident prone, but who would know that looking at him? He also had a salesman's voice and between that close-the-deal charm and the physical backup we never had any people problems when working with Cadillac. Now here he was staring at his buffed nails and questioning the meaning of life. It was totally out of character. It brought out my motherly side.

"Cadillac," I found myself saying, "you been working too hard, why don't you lay off and go fishing?"

"Yeah," he said," I could take the camper and my boy and go up to Klamath and get some trout. Just the two of us, be off by ourselves for a week." His eyes glazed over and he started spinning the web. I knew he'd never do it, probably not even on his three-week vacation, because by then some other lien on his life would have come due, but the daydream was like the donuts he used to buy for the all-night crew, and it pumped the moment up.

The Chief was about Cadillac's equal in the Don Juan department—he even conducted a curbside romance with a young rail buff during the Starlight's seven-minute station stop in San Luis Obispo. When rumor had it they were engaged, I could picture the entire train crew rising at the words "Speak now or forever hold your peace." Fortunately, she decided against it on matters of religion, before, as Sunny put it, "all her arms and legs fell off" from some probable social disease.

When Cadillac and the Chief caught a run together, the testosterone level would melt the change in your pocket. Conquests were always dissected in diner conversations, but the stories stayed strictly within the genre. The women were always hot, ready, and impressed. They always wanted more than they got, were sentimental, wrote follow-up notes, made phone calls, made fools of themselves. Cadillac and the Chief were always scouting for the next hot skirt at the next stop down the line.

"That little train attendant, the blonde from the Valley, man is she a hot number," the Chief said as the diner climbed toward the black rock saddle in the shadow of Mount Shasta.

"Good in the rack?" Cadillac asked, leaning in toward him, his boxer's hands knit in a cat's cradle, both of them playing to the house—myself, at the opposite table, one of the boys, pussy under glass.

"Oh man"—the Chief rolled his eyes—"on the layover, and I do mean

*lay*-over, I had her bouncing off the walls, and I tell you she loved it." He leaned in for the stage whisper. "And I fucked her everywhere. And I mean everywhere. In the morning, we were crawling. I said, 'Baby, I'll pump your gas anytime.'"

"Hey," I said, breaking in. "Why don't you guys hold each other's dicks and see who can shoot the farthest?"

"I like her," Cadillac said. "She says just what's on her mind."

"Yeah, I guess so," the Chief muttered as he glanced over at me. Then he turned back to Cadillac. "So you get any last trip?"

Perhaps I had just become sensitized, as in allergic, but I started noticing the attitude everywhere—even in people I considered enlightened.

"She's too fat," my pal Bill Sheehy pronounced, his eyes scanning the polyester stretch pants on a woman walking through the Nugget dining room.

"Too fat for what?" I said. "You don't even know her."

"But I don't want to fuck her," he said.

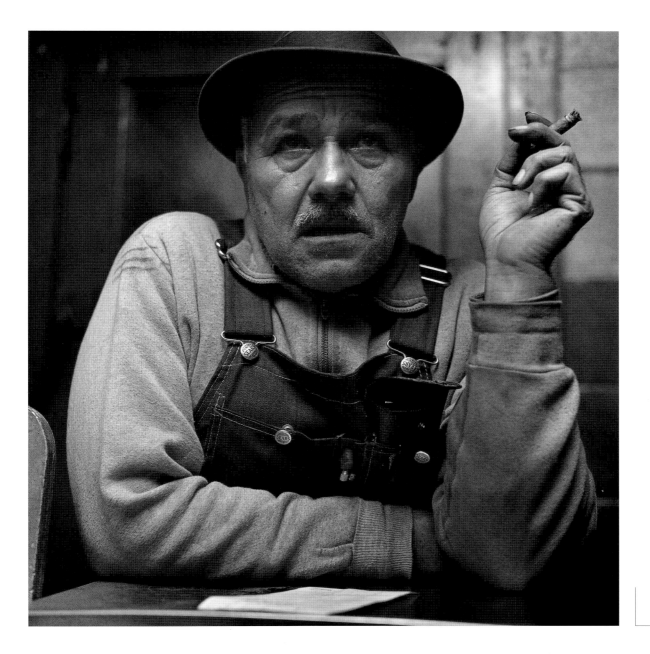

**carman with cigar**

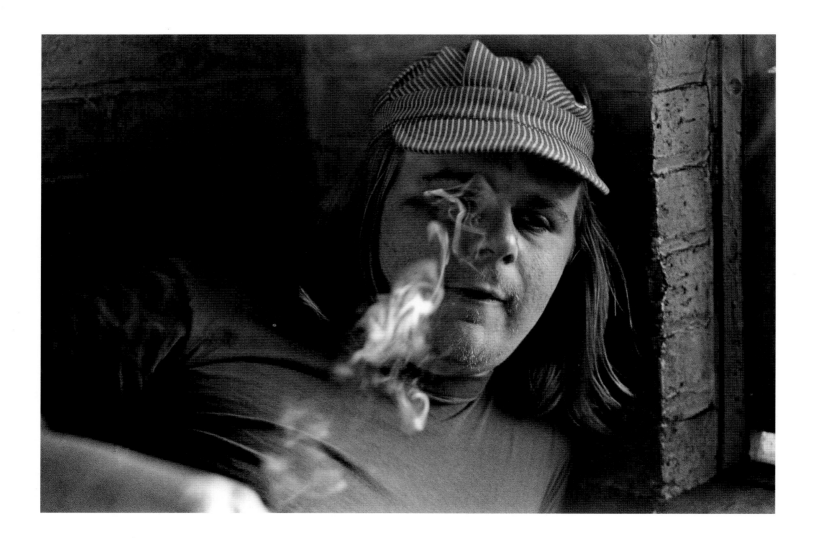

yardman smoking

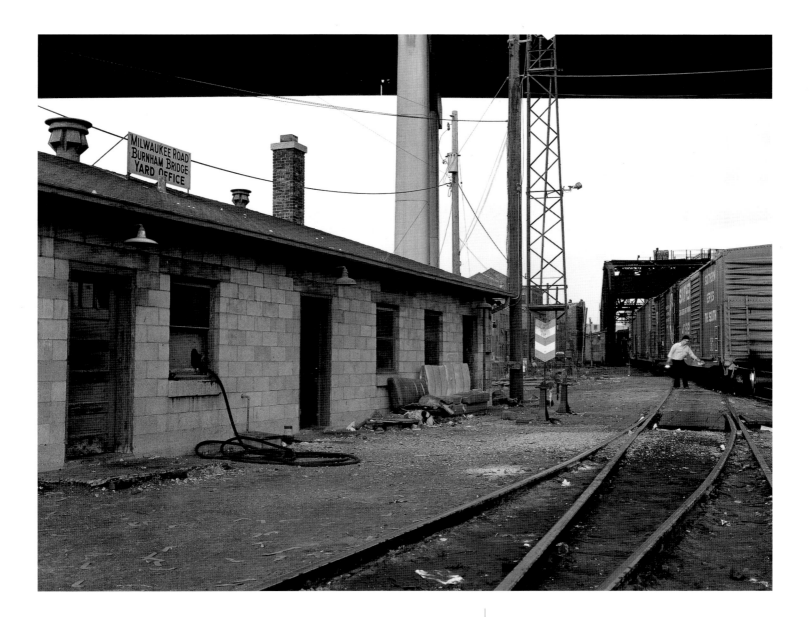

bleeding cars

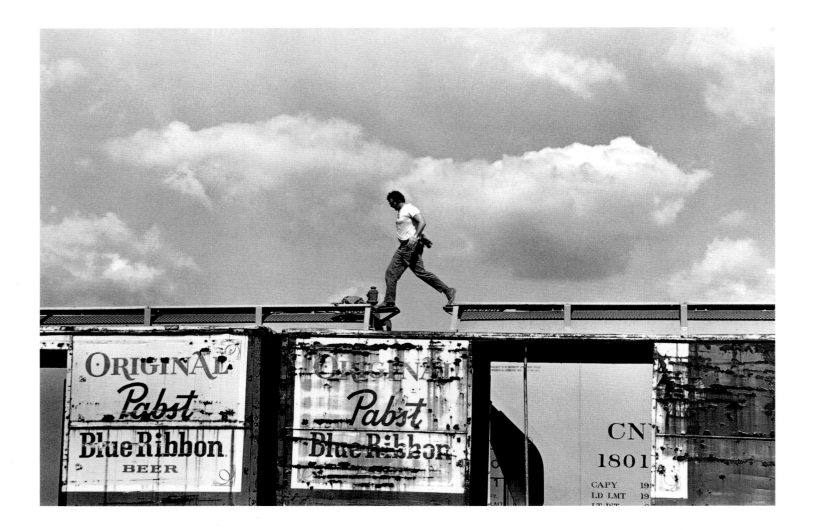

cat walk

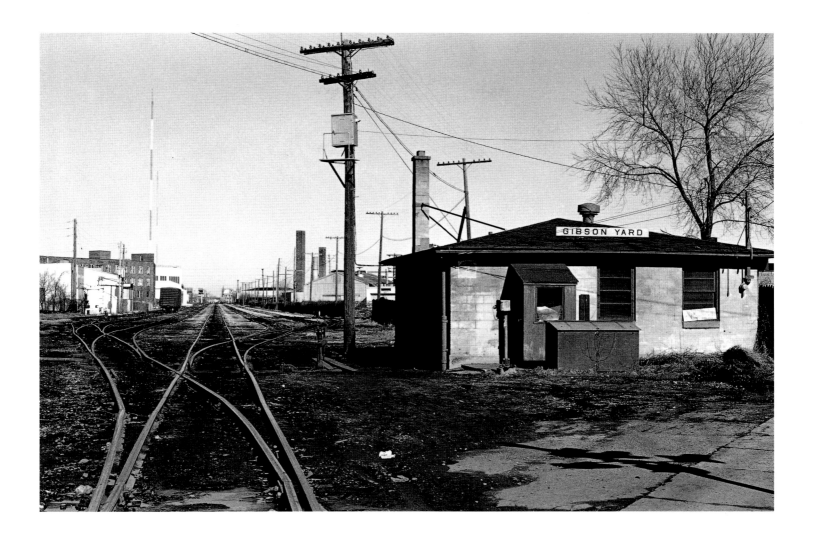

**Gibson yard**

**square shanty**

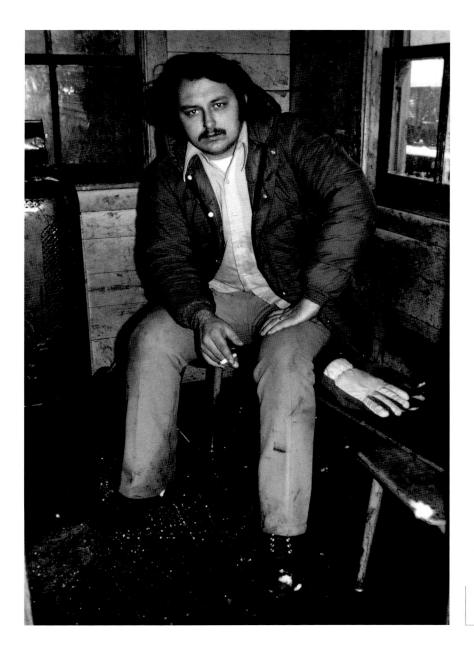

switchtender with cigarette and gloves

## The Kindness of Strangers

Freight railroading has its important habits, starting with protecting yourself and then the lives of the rails you work with. These habits have to be so ingrained that you follow them in your sleep, without choice, or one night the unacceptable will occur. The thing that scares me most is when I vary a routine without meaning to. It always makes me wonder if I should take time off, or examine my whole psychology to see if there's something wrong I need to look at.

On passenger trains, the first importance is taking care of the passengers. That, I suppose, becomes a habit, too. But for me it never did. It was too wrenching, the degree to which you have their fate in your hands and often the little you can do to protect them.

The Valley Train was a populist train. Twenty-minute stops puddle-jumping from Oakland up through Stockton and down the San Joaquin Valley to Bakersfield. Five hundred people on and off the train, no baggage car and people moving households, large sacks of grain, sporting equipment, divorce-orphaned children, and aged parents. Gang-bangers and families visiting the prison stop. Punk rockers disembarking at Denair. Well-heeled drunks riding home to Bakersfield after eating at the Imperial Dynasty French restaurant trackside in Hanford, often so tipsy they had trouble boarding the train and then so fractious they were liable to pull out sidearms, in keeping with their oil-field character.

Some people never found seats at all, standing in the long lines in the snack bar, us eagle-eyed conductors trying to sort out who had paid from who had not. At times we would lock ourselves in the attendant's room downstairs and pile wads of tickets on the tables, trying to complete our graph of the ridership and escaping from the human crush upstairs.

A divorced parent would sometimes appear on the platform with the fifty other passengers boarding and hand a child and a note to the conductor.

"Johnny's going to Bakersfield to visit his father—would you keep an eye on him on the train?"

And you would have to tell them, in two minutes, that no, you could not keep an eye on him without locking him in the attendant's room. Some obviously delusional dream of train travel in the old days, in spite of the visual evidence before their eyes, of genteel passengers seated in spacious cars under the fatherly supervision of the conductor. This was not the Valley Train.

Worse in a way was the Aged P. who could not be regulated but who wandered away from her car and suitcase, only to panic at her stop when she could not find them.

"What color was the bag, ma'am?" I'd say, the head and rear end of the train having become indistinguishable to her, easily enough, by the fact that it was moving. My own mother having spent time in precisely this type of confusion, I would hold up the train—minutes we had to account for later, searching all the cars while the engineer yelled at me over the radio.

"You can't win with 'em," the other assistant conductor advised me, referring to little old ladies in general.

One rainy night we overshot the station at Antioch—only a street corner beside the tracks—and I opened the door beside a wet field several hundred yards from the street and the passengers clambered out into the night. A frail little old lady stood beside me looking out, mildly trembling.

"Is someone meeting you?" I said, and she mentioned a son, but it seemed impossible to ask her to step out into that field, all by herself, in the hope she would find him. A tall husky man in a baseball cap was getting off, too, and I put her hand in his and said, "Take care of her," and handed her suitcase off in the rain. "Highball," I heard the conductor shout as we started to pull. Minutes later he was chewing my ass for delaying the train and the hoghead's for missing the stop, and even the few moments I had stolen for her were held against me.

**Ducks**

I was working bags the morning in July Bill Sheehy turned up again as an extra conductor. It turned out he had loaned out to Amtrak too, and we had the Coast Starlight run to Santa Barbara—a daylight cruise down the coast with a young, fun crew. It felt like trainjacking.

We pulled out of Oakland on time and I set about rearranging my baggage cars, getting the luggage sorted by destination and the next-stop stuff next to the doors so it could be shunted off fast. The baggage job was my favorite— a Zen retreat where things needed to be ordered and you could cleanly concentrate on the now. Of course, things did not always go smoothly. Station Services in Santa Barbara was still retrieving scattered clothing off of tumbleweeds from the run during which an unattended child made his way to the baggage car and started pitching suitcases through the open doors. His father was spending his trip in the club car, and baggage-car doors that wouldn't close were par for the course on the ancient equipment we were using. I myself had used a broom handle to keep the rear door on the train closed on numerous occasions.

The L.A. car was dusty and messy when I got on, and I picked up a large shallow box and was about to stack it when the box started squirming. It was like the time I put my hand into a bag of ermine feet at a rummage sale. I screamed and dropped it. "Cheep, cheep, cheep," the box fluttered back. I

could now see little beaks poking through holes along the sides. It was full of baby ducks—packed in like soon-to-be down pillows. "How cruel," I thought. "Making me into a duck killer. Those assholes didn't even give them any water." I looked at the box address. "Hanford"—a stop on the Valley train. These ducks weren't even going in the right direction. It would be days before they got to their duck farm, or wherever they were going. It was ninety-five degrees in that baggage car. This was duck abuse. This wouldn't fly.

So I got on the radio and asked for help. Bill came back and took those little ducks in his big strong arms and put them in first class.

"The chief won't mind," he said. "Those ducks might have died."

By the time I got through stacking the bags, the baby ducks had become celebrities. The waiters had brought in a dishpan and the ducks were getting baths. There was duck down all over the first-class cushions, and duck shit on the carpet. Bill was busy taping over the shower drain to make a duck pond with a waterfall. The rear man was letting the ducks answer the radio.

"Detector on the right, Amtrak number twelve."

"Cheep cheep cheep cheep."

We looked on the mailing coupon. Thirty ducklings at $7.00 each. Could we somehow ransom their lives? Passengers were already offering to buy them.

"We could sell these ducks and just mail this guy the money. After all, dead ducks aren't worth anything."

"Yeah, but it's U.S. Mail. Tampering. A federal offense. We have to call Amtrak. Lay it on them. Our responsibility to get these ducks there safely. We could take them off in Santa Barbara and put them on a bus to the valley. That's the only way they're going to make it."

"Well, these ducks are going to make it," Bill said, his eyes glazing over momentarily. "There's no way I'm going to let these ducks down. Get it? Duck down?"

"Careful you don't get imprinted," I said. "Ducks do that. That little duck is already trying to act like a conductor." I tore myself away. The compartment was starting to smell pretty rank, with train attendants, waiters, the train crew, and thirty ducklings. "I'm going to the ten car to read. Let me know if you need a duck watch."

"No problem," Bill said generously, a duck balanced on his conductor's hat. "I think we have the situation under control."

We reached Santa Barbara at 5:00 P.M.. By now the ducklings were re-packed and awaiting their fate. This is where we, and hopefully they, got off. Bill ran into the station after telling the new conductor to hold the train. Five minutes later he ran out again and highballed the train off. His red face signaled bad news.

"Goddamn that chickenshit trainmaster. I told him we needed to do something, but he wouldn't go for it. Said we could get in trouble for tampering. I told him there was going to be trouble if anything happened to those ducks. I'm calling the Humane Society and the post office and the L.A. station and that guy in Hanford and I'm gonna tell 'em just what I think of this situation. This is murder."

I watched the train pick up speed as it passed the last road-crossing out of town.

"Well, Bill, at least they got a drink and some food on the way down here. Maybe they'll make it. It's just one more day."

"Yeah," he said, "they'd better make it. Or I'll strangle that trainmaster. Goddamn front-office man. We get stuck with the shit."

"In this case, whoever gets that bedroom does. I don't think you made the L.A. chief too happy, Bill."

"No," he said, cheering up. "Did you see his face when he got a whiff of that carpet?"

"Hey, Sheehy," Barbara the station agent said, coming up behind us on the platform. "You got a visitor at the station."

The way she said *visitor* meant that we ought to all go and take a look. Bill looked confused and then a light dawned and the tragedy of the ducks fell off the flat edge of the world.

"Oh God," he said. "It's that girl who sent me a picture of herself without any clothes on. I mean, she was a trainee I met on the train and she goes and sends me this picture. Wanted to know if we could get together. Now what kind of a person would do something like that?"

The woman draped over Barbara's desk was five-two with another three inches of spike shoes. She was wearing a white plastic miniskirt that showed things off and a white leather bolero that pushed things up. She had a blonde bubble hairdo and white lipstick. She was a nineteen-year-old beamed up, unspoiled, from the sixties.

"Well, Bill," I said in what I hoped was a guilt-producing tone of voice, "I

guess you won't be losing sleep over what happens to those poor defenseless ducklings, will you?"

"I guess you won't be going out to Woody's with us either, Bill," the engineer put in.

"If you get tired, Bill, I'm in room 37," Ray the rear brakeman offered.

And off they went, the conductor and the plastic girl, as the reddening sun dropped like a gob of butter on a hot grill and the palm trees blackened and an inky breath of fog unrolled itself from the sea. We all went to the motel and checked in and then to Woody's and then to bed, where I tossed all night like I was still on the train only the lights were out in the baggage car and there was a stiff in there named George and the ducks were lost and we had to find them.

## Brother's Keeper

In the morning the plastic girl was gone and our train was on time and we heard no more about the ducks or the carpet. On Amtrak, every day was a new day. The restaurant kept on rolling down the line. Bill took off booming soon after that—to Milwaukee, rumor had it—and I didn't see him again for about a year. Then he was back and we were working the Zephyr to Reno on a hot day in early summer.

The Bay and the delta kept a cool ocean fog, but as we entered the tule marshlands toward Sacramento it got hot and sticky fast. Pollen was flying in the baggage car and my eyes were bothering me and my polyester jumpsuit was sticking to my white starched shirt.

We crossed the Sacramento River just before our station stop and I opened the baggage car doors as we entered the iron bridge over the river to look down through the girders at the green water below. I saw motorboats and bums and the old engines of the railroad museum and the humid mud of the riverbank. An intersection of river and rails, both following the same route down the Sierras.

The baggage cart met me on time and we were loaded and unloaded with ten minutes to go on our advertised departure time, so I opened some doors for a cross breeze and sat down on a likely bag and waited. Ten minutes went by and we still weren't moving, so I looked back down the train. I could see

Bill and Ray, the rear man, in a knot with some passengers. Five more minutes went by, and then Bill gave the engineer a highball and we started creaking out of there. Curious, I stepped out of my jumpsuit and headed back through the train, picking up tickets and fielding the inevitable requests.

"How many stops before Reno, Miss?" "Do I get a pillow?" "Oh, we get a girl conductor today, Bert. How about that one." "When does the snack bar open?" "How fast are we going?" "How do you work these leg rests?" Clutching my wad of tickets, I met Bill and Ray in the eleven-car vestibule.

"You should have seen that guy," Bill told me. "God, this makes me feel bad. I just had to tell him he couldn't get on the train. The guy had no arms and legs. Somebody had to have left him on the platform. No way he could have gotten out there by himself."

"So what is this? Did he have a ticket?"

"No," Ray said, "He wanted to buy one on the train. He acted like he was running away from something. He just wanted to get out of town."

"He was running away from his brother—the asshole who dumped him off on the platform. The guy started to cry, man. I just can't stand this shit. Who would just leave his brother like that?"

"So why didn't the station agent sell him a ticket? Why didn't he have anyone with him? Where was he going, anyway?"

"I don't think the guy cared," Ray said. "I think he was running away. Any place but this place."

"Well, I told him about Reno," Bill said. "I told him I wasn't just going to leave him in Reno with nobody to meet him and no money. Bad things happen to you in a place like Reno. And then he started crying."

"And swearing," Ray said.

"Well, wouldn't you?" Bill said. "I told the agent to call Social Services. I told them they had to do something for the guy. Jesus Christ!"

Bill was right about Reno. Now that was a cold-blooded place. The guy who drove the bus to pick us up at the depot doubled as a goon who beat up "bums" in the parking lot. We could hear him on his radio talking to his goon buddies.

"Transient in the east parking lot. What should I do about it, Fred?"

"Get him out of there." Turning to us for agreement, he said, "We know what to do with panhandlers around here."

"This place probably creates a few, don't you think?" I said nastily.

"Well, we don't let them live here like some places do. They get the message pretty quick it's time to move on."

He turned back to his driving. I didn't count. He was wearing a baseball jacket with a casino patch. He was driving a van.

The return trip the next day went smoothly enough, given that the Zephyr was three hours late. That should have given the station clerks plenty of time to get their cart to the baggage car on time, but no, I had to wait for them to thread their way through the passengers and then put the pressure on me to throw the bags off fast. Bill walked up to the baggage car to ask them about the paraplegic. I knew it had been bothering him. The part about the brother, especially.

"Hey, it isn't my problem," the agent said coldly. "I had a special agent out there and the guy got hostile. I think someone came around three or four to pick him up. Someone from the hospital. That's what I heard. I was off by then and I really didn't care, frankly. But I think they came to pick him up. Anyway, he isn't here now, is he?"

"Are you going to talk, " I said, "or are you going to throw these bags?"

"My favorite TBM," the asshole said, flirting with me. "You've always got a smile."

"I'm going to drop a dime on that guy," Bill said, when the train had gotten underway. "I'm going to have his job. Leaving that guy out there all day. What's the matter with people? What's fucking wrong with them?"

I looked around the baggage car—my blessed rage for order—the sanctuary I'd staked out for myself from the ticket-taking, passenger-interacting part of the job. I could stay in here at least another forty-five minutes stacking the boxes of *Amtrak Express* magazines we loaded at Sacramento. Today I wanted to stay here the rest of the day, surrounded by suitcases in neat piles. Bill seemed to feel the same way and sat down next to me on an overstuffed garment bag. I left the baggage doors open to watch the river roll by. "By the way," I said after a while, "did you ever find out about the ducks? Did they make it to Hanford?"

"I called about that," he said. "It was all a dumb mistake by the post office. They aren't supposed to ship livestock on our train. They were supposed to go by bus. I told them the Humane Society would be on their case if they ever did anything like that again. But would our boss do anything? Not on your life. People are fucked. Do you know that?"

"Yeah," I said. "I know they're fucked. And we're on the train. And I don't even get to have the plastic girl." The green Sacramento was rolling underneath us. The iron girders flashing by like frames.

Bill looked at me, the wheels turning in his brain like one-arm bandits. No jackpot came up.

"Oh yeah," he said. "Her. What do you think about a woman like that, anyway?"

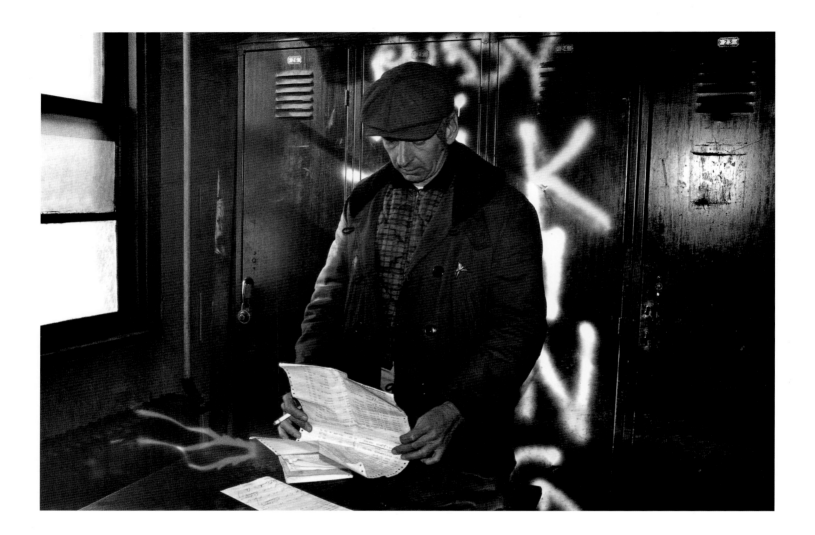

yard list

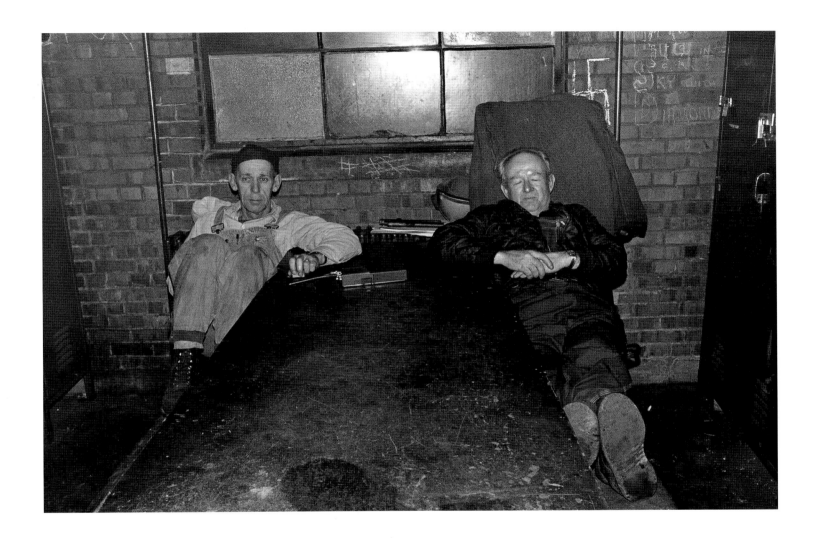

waiting with radio

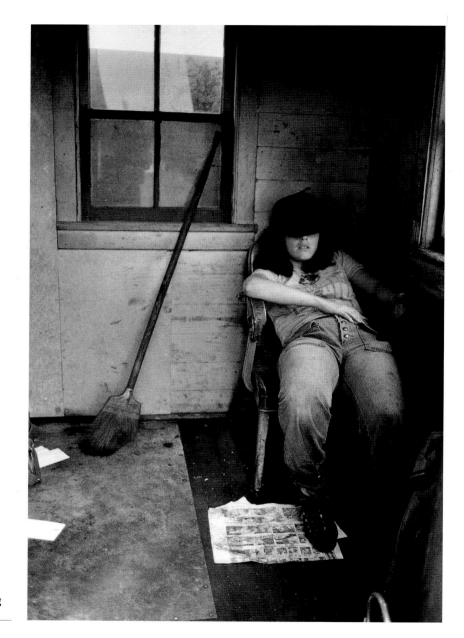

switchtender resting

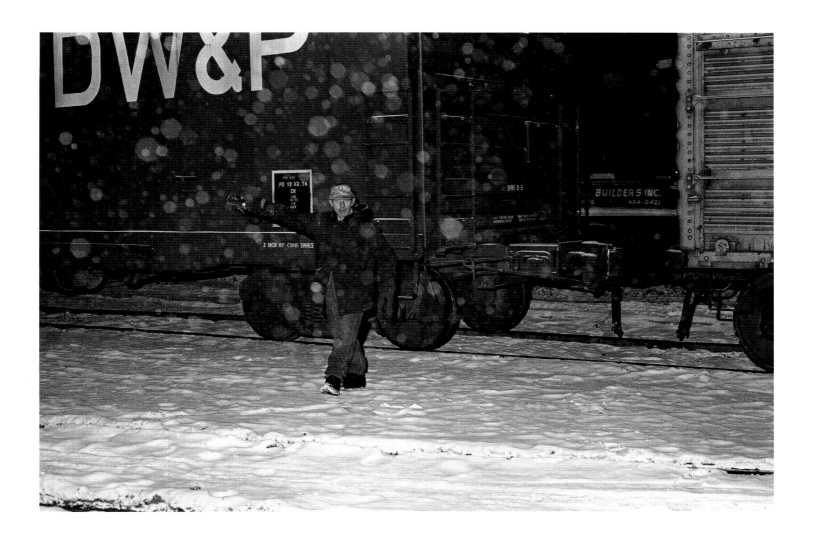

signal and snow

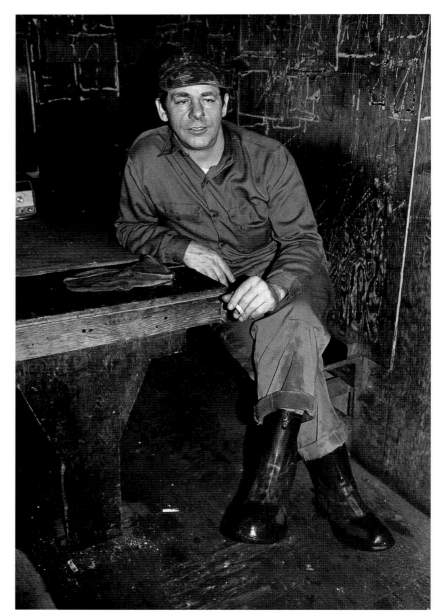

night switchman in the shanty

roadmen with their grips

brakewoman, night road call

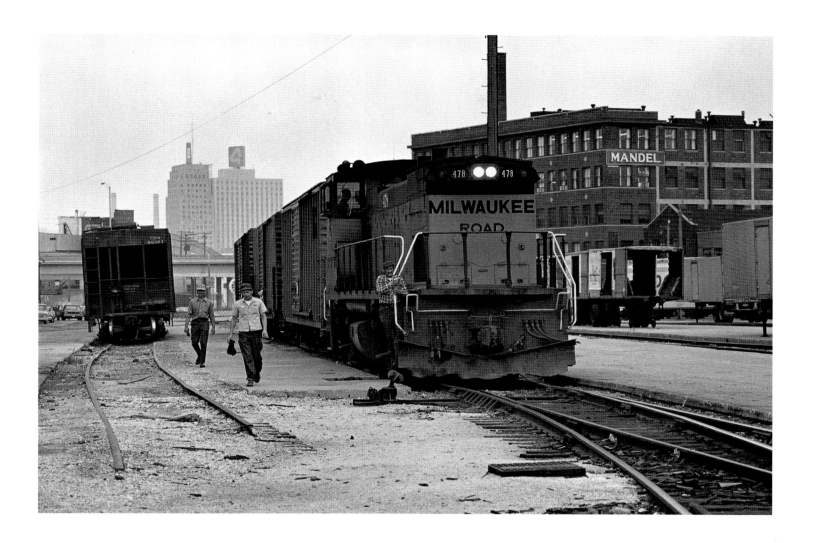

local switch crew

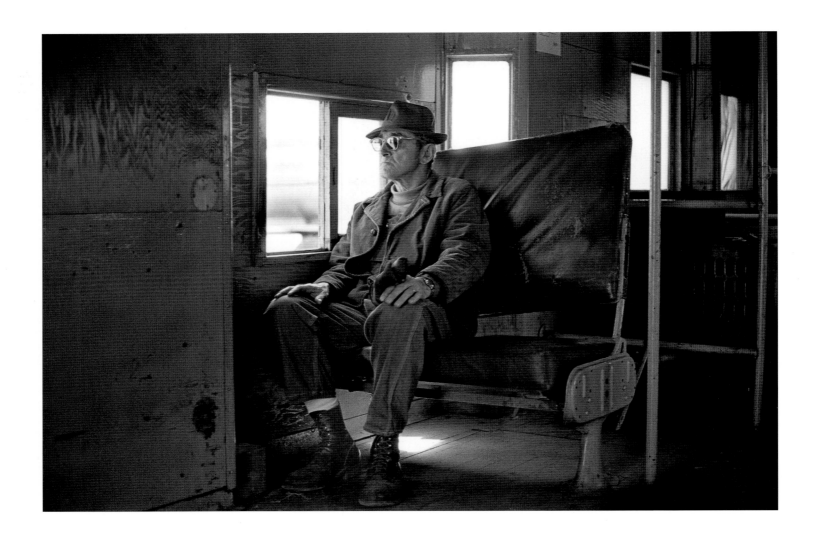

**watching from the caboose**

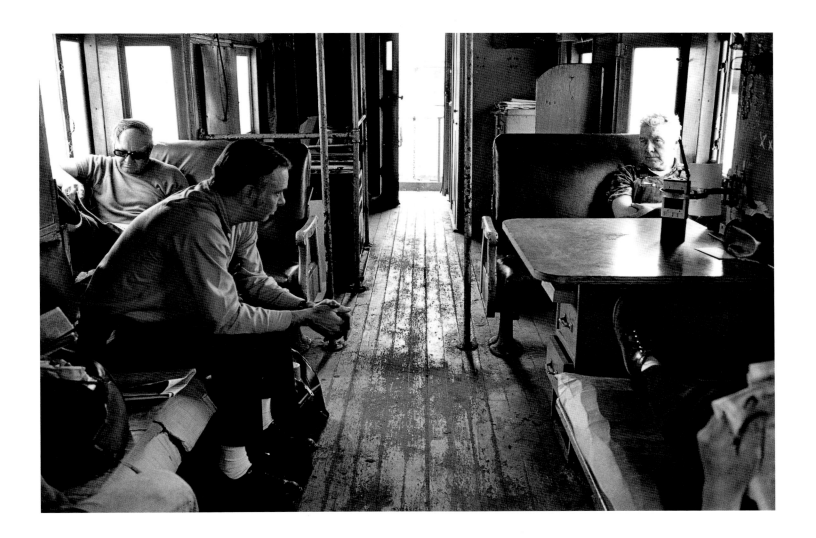

in the caboose

## The Verdi Gang

The California Zephyr became my regular run and the baggage car my regular job. I'd work the baggage stops at Martinez and Sacramento, and then just watch as the engines began their long, slow pull up the mountains. It used to be that the foothills were mostly empty, but now they are filled with brand-new single-family houses. They stand there like concepts on a canvas, geometric and treeless. Whoever lives there is on the freeway doing a three-hour commute, and the large, empty backyards just sit there soaking up money.

It makes me sad to see these houses rolling by, and I'm glad when we climb into snow country where there are places you can't get out of in a hurry. Colfax is our last stop before the summit, a cold place in winter with red earth and tall pine trees and an aqueduct paralleling our tracks—in California water is always being carried somewhere. It's here I start to envy the cabins up in the high mountains where people can't leave every day, where the woodpile is a four-month affair, hardwood stacked five cords high, and the roofs have a good snow slant, and there is a front porch in the sun as the Zephyr goes by in the early afternoon. I start making up stories about who gets to live there, and I think, "God, those people are rich."

Sometimes there are people who stand next to the rails and wave the train by, or come out on their porches to watch us. Sometimes they're regulars

who probably have some story about the train like my story of their cabins. And usually the twain never meet.

"SP Amtrak number six, Verd-eye roll-by on the fireman's side."

The engineer on the California Zephyr calls out the railroad lingo for the siding at Verdi. A roll-by is a visual check of passing trains that railroaders do for each other on the road. The engineer calls it on the radio to the rear brakeman, who then watches for a high-sign—a "highball"—from whoever is on the ground.

Two women, mother and daughter, are standing beside the track, wrapped in trench coats against the winter cold. The taller of the two holds a scanner radio. Both are blonde. Both are quite beautiful. They stand close to the track, and the highballing Zephyr whips their clothes around them as it suctions by them, engine and ten cars rocking.

"Highball the Verdi roll-by, number six. Highball the Verdi Gang."

The Verdi Gang—once the name for a bunch of train robbers—now refers to a Nevada family that has broken through the barrier that separates railroader from rail buff. Barbara, Susan, and Paul Conradi have achieved this through the medium of the cookie—bags of homemade chocolate chips, each with the crewman's name on it, waiting at the Sparks train station after a run. The Conradis know every train or engineman by name; they know about their families, keep up on their lives. The usual encounter between rail buff and railroader is not at all this way. The buff wants to know about the motors, the track, the radio frequency. All the mechanical details of the job. And the brakeman stares out the window, wishing he were going to be home tonight, and angry at the rail buff because he constructs a fantasy, while the brakeman must live it. And so the cookies were a stroke of genius, like a trail of crumbs leading through the forest to home.

"Living in Verdi we were particularly interested in the train," Barbara recalls. "We looked at it in the distance going by, and finally one day we said, 'Why don't we go down by the log by the river and wave at the train?'"

Waving at the train soon became a Sunday-night tradition. Every night at 6:30 P.M. they waited by the tracks for a headlight or the sound of the Zephyr's whistle. Soon the engineers began to know them and return their highball.

"One night we said, 'Why don't we go up and get a little closer to the train?' And so we went up to the Verdi post office and climbed up the hill,

and, sure enough, we were close—ten feet; that's how close we were. Oh, we liked that. It was super that you could be so close to something so big and so massive as that and it still stayed on the track."

That very night they followed the train into Reno and pulled up beside the big Amtrak engine.

"We looked up at the engine and the engineer looked down, and he just grinned from ear to ear. He says, 'I don't believe this.'"

The engineer and fireman handed down an Amtrak crew first-aid kit, the only thing they could find lying around, and the Verdi Gang was overwhelmed. The train had been friendly back to them. They had established communication. All week long they plotted out their next move.

"We went to a Hallmark card shop, and we thought, 'What would be an engineer color?' Black. So we got these black little bags with handles and filled them full of candies and cookies and a note saying how nice it was they acknowledged us and that we loved trains. Next week when they came in we handed up these little bags to them. Well, they liked that."

As rumors of the cookies spread, soon the regular conductors and brakemen were also waving at the Verdi Gang and also picking up their bags of chocolate chips at the Sparks station.

"They found out we were giving the engineers stuff, and that started my cookie situation."

Soon the Conradis knew all the regular crews that turned around in Sparks, including the crews from Salt Lake. Their cookie roster then expanded to include the on-board service crews—train attendants, cooks, stewards, and chiefs.

"It just got crazy. I was not only giving cookies to the incoming crew, but to the crew that leaves to go east. They found out about the cookies. I guess there's been over 2,500 cookies I baked, and now I'm into cupcakes."

Susan Conradi has earned herself a railroad name—the Verdi Trainmaster—for rolling by freight trains. Railroaders watch passing trains carefully for dangerous defects and one day Susan saw one.

"I was down at a special place by the river and here comes a train. They were carrying lumber and one of the straps broke and they had lumber strewing all over the place. I immediately went back home and called the depot and reported it. I report anything I see—brakes, smoky engines. I'm the hero down at Sparks."

Railroaders do remember a favor. One Christmas, an Amtrak engineer named Paul Blake had a massive heart attack in Reno, leaving him comatose in the week before he died. Since this is our layover location it was a few days, even weeks, before most of us heard about it. Trainmen and enginemen are always on the move, and sometimes it's even hard to keep up with your own friends or family. I know I thought, "What if that had happened to me? Dying in some turnaround hole-in-the-ground with nobody there and nobody even knowing about it." Then I heard that the Verdi Gang had been to see him. A few weeks later a company official rode the train to Reno to bring the ashes home on the engine. They were sitting in a small red knapsack when I came into the office before a run.

"Life of a railroader," I thought.

"They should have sanded him over the summit," someone said. And we read our orders and got on our train.

As it turned out, however, Paul Blake hadn't been entirely alone as he lay in a coma in the Reno hospital. The Conradi family were listening to their radio scanner and heard about the incident. They got themselves into the intensive care unit and sat and talked with him. They held his hand. They bought a card and signed it with the names of everyone they knew on Amtrak and read it to him. "We said, 'We're friends of his and we're basically the only family he has in this area,' and they let us in," Barbara told me. "They said, 'All you can do is talk to him,' and I talked to him like he could hear us, and I told my husband, 'I think he can hear,' because he always squinted his eyes. I talked to him and said, 'Please get well; I'll promise you cookies, anything. If you'll just get well.' It was as if we were family—all that he had."

Barbara remembered how she got to know Paul Blake. They had been in Sacramento that day and had hit upon the idea of passing notes up to the engine crew of the two Zephyrs when they stopped in the Sacramento station. Paul had been working that day and Barbara says he cracked one of his rare smiles when he read the note she handed up to him.

"He says, 'Oh, you aren't going to be there? I have a new fireman and I wanted to show you off.' And I think it was the first real rise we got out of him. He says, 'I look forward to that little spot in Verdi—that you're waiting for us.'"

"Sometimes," Barbara continues, "we think maybe it's old hat to every-

body and they're tired of us, but we can't seem to give it up, and we eat early now. It's changed our lives. Now Susan and I are usually dressed by 5:00 P.M. because the train's due through there at 6:25, and I have to make sure Paul's fed and everybody's fed, and usually by ten-after we get in the car and drive to see the train. They know whether it's snow, rain, sleet, or whatever, they say it's the faithful Verdi roll-by."

The railroad has many landmarks associated with it. Beside the most remote tracks in the desert one finds crosses that mark the spot of a death. Little towns like Verdi were created by railheads and sidings, watering places and roundhouses. I suspect the Verdi Gang will find a place somewhere—in a song, or a story, or in the cookie roll-by called and highballed as a secret among ourselves, as Zephyr trainmen and engineers.

Cabooses are a thing of the past on the modern railroad, which has now gone to two-man crews. The caboose used to be the conductor's castle, with two beds, a coal-oil stove, a toilet, two chairs in the bay windows or bench seats up in the cupola, and the conductor's desk—the most sacred place on the train. The brakeman who rode back there was the conductor's slave, "taking care of the old man," keeping the stove warm, the floor swept, and walking the length of the train to inspect it whenever it stopped. The last word on the train belonged to the conductor's valve, a red handle that, if pulled, threw the train into an emergency stop. The long-standing feud between conductors and engineers resulted from the use of this emergency valve when, for example, the engineer couldn't control the train's slack and knocked the conductor out of his chair and woke him up.

"If you ever look out that window and see a dark signal," an old conductor told me one time, "you pull that valve and save your job. By the time you walk up to the head end you can think up some story why the train got past it."

I heard a good caboose story from Rolling Thunder, who was a brakeman on the Southern Pacific railroad in the 1940s. He was also a Native American medicine man who had a big cult following in the sixties. There was even a deli named after him in Santa Cruz.

I heard about Rolling Thunder when I was up in Gerlach, Nevada, but it wasn't until I met a disciple of his that I found out where he lived—Carlin, Nevada, a place I remembered well from my own days braking out of Ogden, Utah. Those memories did not impel me to hurry, and it wasn't until the next summer that I headed my truck east and drove the ten hours that it took to get me to Sturgeon's truck stop on the main street where I put a quarter in the phone and called up Rolling Thunder.

"I'll send someone down to guide you here," he said, "By the way, you aren't on your moon, are you?"

"Moon?" I said.

"Your menstrual period," he said

"Uh, no," I said. "Not on my moon."

"O.K.," he said. "Because we have one woman on her moon here already."

Soon what looked like a brakeman's away-from-home car appeared with a friendly guy in a ponytail driving at the wheel. We drove over the tracks that made up the Carlin Southern Pacific freightyard and pulled up to a rambling old house facing the desert and more train tracks—this time the Union Pacific's main line. A sign proclaimed, "Welcome to Rolling Thunder Land."

I waited under an arbor until a clear-eyed man wearing a ribbon shirt was brought out to meet me, a wheelchair now necessary owing to the loss of a leg from sugar diabetes. His beard was grey, but he seemed much younger than seventy-four. He told me he preferred working as a brakeman, though he'd done all the jobs, fireman, hoghead, trackworker, conductor. I understood that—brakemen are the young and the restless, and they keep that flair, whereas conductors settle into immobility and crankiness. Brakemen become developed eccentrics. I am, myself, a brakeman.

Rolling Thunder told me he was hired during World War II when they were shorthanded and willing to overlook the usual prejudice. On the job, however, there was a lot of it. He often found himself between the cars giving some fellow rail a lesson in payback.

"And I never lost a fight," Rolling Thunder told me emphatically. "In the Indian religion we don't believe in turning the other cheek. We take a step back, but if the other person keeps coming . . . "

It seems he had habits the other rails just couldn't get used to—like stopping the train to help hobos into the freight cars, finding them a safe place

to ride, and taking them his lunch and a few bucks to get them down the line.

"It used to make everybody mad that I would stop the train to help the hobos into those boxcars. They'd say, 'We got to make time; we got to go.'"

He leaned back in his chair and propped his short leg on the table. The light was edging the leaves of the arbor in yellow and peripherally I could see them dancing. I was aware of a pause.

"I guess I would like it remembered of me that I helped a lot of people and I fed a lot of people.

"Sometimes I'd take the hobos to the Milepost or the Green Lantern and buy them a dinner, so I could see that they would eat it. The law around here was pretty good then, too, and the sheriff would let them sleep in the jail overnight so they wouldn't freeze to death and send them on their way in the morning. Why even now people are breaking windows in Elko in the wintertime so they can go to jail and not freeze to death.

"Groceries were cheaper then and I'd fill up my old surplus van with produce and take it out to the reservation. They were always glad to see me coming because I never went empty-handed. Nowadays you could spend two hundred dollars and only have about five boxes of groceries."

Rolling Thunder came to live in Carlin after about fifteen years on the railroad because he had a chance to work steady. It was cold and isolated and not everybody could live here. He remembered the first winter he arrived.

"The winter of '68 was very cold and I had just come out to Carlin. I got on the job with a very tough old conductor, one of the old-timers that was hard to get along with. But he was going to like me because I'd take care of things, like shining up the caboose light, and wiping off the conductor's lamp, sweeping the ashes from the coal stove, cleaning up the dishes, but never washing the coffee pot because that was something you did not do was wash that coffee pot—I guess he figured that would ruin it forever, so I didn't wash that, but then there was this dust on the floor and I didn't want to sweep it because that would ruin what I had cleaned already, so I just dropped some drops of water on it to settle the dust, and then to settle the dust real good, I poured a whole bucket of water on it and the whole floor of the caboose just froze solid like a big sheet of glass. Well, that conductor climbed on with his arms full of bills and paperwork and his feet took off and his butt came down and I'd hate to repeat what he was saying but I

knew enough not to admit to that floor or he'd have set me out right there. So when he came to a stop and was going on about what blankety-blank idiot watered the floor I just pointed out the window and said, "Mormons," because I knew there were Mormons somewhere around here. Well, those Mormons' ears must have been burning all the way to the temple in Salt Lake City."

"Was the caboose moving when he got on?" I asked.

"No," he said. "Once it started moving we had to stay in our chairs the whole time. That conductor was a tough old guy. He used to carry a gun and make the hobos pay or he'd throw them off in the middle of the desert."

I looked around at Rolling Thunder's backyard. There were about five or six trailers where guests might stay and numerous signs instructing visitors how to do this or that. A large Texas-style barbecue was being fired up for dinner—steaks that a visiting Cherokee had brought with him.

"You're not a vegetarian, are you?" Rolling Thunder inquired.

"No," I said, "I'm a railroader."

"That's right," he said, "That means you eat what you can get when you can get it."

Knowing that he had retired from the railroad after thirty-six years and still lived, as he put it, "between the tracks so I don't get lonesome," I wondered if it had stayed difficult the whole time or if he had found some way to harmonize the way he lived with the job and his fellow rails.

He told me that the officials had let him take time off when he needed to go to the reservation or do things he regarded as part of his religion. That was, in fact, one of the gripes I had heard about Rolling Thunder on the railroad grapevine—that he "never worked" and that he wasn't a "real Indian" because Rolling Thunder wasn't his "real name" and he "looked white." But then, I had never heard a rail say anything complimentary about anyone anytime. There is a reluctance to go outside the insulated world of the work even in conversation, as if everything about the outside world is unreal or suspect.

"I spent the first fifteen years fighting it," Rolling Thunder said, "but at a certain point all of my life had to fit into one whole. I started praying with tobacco leaves before getting on the engine, and started having good trips, good weather, and started getting along with all the white guys. I started having good, boring trips. Then people started doing what I'd been doing all along—you know, like helping the hobos."

I had been listening nonstop under the arbor for about three hours when a woman who was visiting from New York came to help Rolling Thunder join the dinner deliberations. He made an adjustment to his chair, looked up at her, and said, "There, the brakes are off."

"Highball," we both said simultaneously. She looked a little surprised at the joke.

There were about five of us at dinner, not counting the one who had a fever and couldn't eat, and the woman who was "on her moon" and staying in the moon lodge trailer doing beadwork and eating "white food." Women on their moon were "too powerful" to be around men at that time and had to be ministered to by other women and their presence "smoked out" of communal areas by sage smoke. I had been "ministered to" about three days in my whole life and I found it a hard concept to grasp. It sounded good, though.

After dinner, Rolling Thunder told me about a dream in which the railroad had called him back to work, and there he was running the engine again and checking his watch for time.

"You know," he said wryly, "I kind of hope it doesn't happen."

I got a different callback the next day, when I awoke to find that I, too, was "on my moon." Although I was tempted not to mention this, I didn't want to be responsible for Rolling Thunder blowing a fuse. Of course, I also doubted he would turn down a main-line run for similar reasons.

"Oh, that always happens when women get here," Rolling Thunder said. "They come here to get healed."

I took a look at the view from the moon lodge—sagebrush unrolling like a grey blanket to the ghostly shapes of the next washbasin range, the regular sounds of the U.P. moving fast freight after fast freight right past my open door. That nice woman from New York bringing me white food. I maybe should have done it, but then the brakeman in me was discontent with one detail—that door wasn't moving. I just wasn't the moon lodge type.

"Why, we were just getting started," Rolling Thunder said when I announced my intentions of visiting Great Basin National Park, "but I guess a woman's got to do what she's got to do."

As I was driving the hauntingly beautiful Highway 97 heading south out of Carlin, with hot springs steaming into the fragrant air and the railroad-flat whorehouse winking goodbye as I crossed the tracks leaving town, I thought

about the other railroad story Rolling Thunder had told me, one too good to be true, but funny enough to repeat here.

It was about a loaner, a young brakeman on his student trips out of L.A. or somewhere like that who got on a run to Sparks in the winter, the kind of winter that froze that caboose floor.

"Oh, he was a real know-it-all and the conductor tried to tell him things, but he would just say, 'Oh, no, that'd take too much time,' or, 'I don't think I have to do that.' And the conductor was telling him to put on his gloves before he tried to get out there and throw those switches because if you touched the iron handles with your bare hands, why you'd stick to it and it would take your hide off. Also to walk twenty feet behind cars in case they moved on you. But he didn't believe any of that was necessary, and so, finally, the conductor says, 'I'll bet you my last dollar that if you go out and stick your tongue on that rail, you'll stick to it.'

"And the fellow says, 'Well, I don't think so,' and goes outside and sticks his tongue on the rail and, of course, he gets stuck there. And he's trying to holler but he can't with his tongue like that.

"So I say to the conductor, 'Don't we have some warm coffee in the caboose or something that we could pour on it to get him unstuck?' But he said no, we didn't that time.

"So he had to go outside and pee on that guy's tongue to get him unstuck. And you know what? The guy wasn't even grateful for that."

## Big Mack

Bob Kreiberg and I caught the Warm Springs Turn one April night right at the start of beet season in Salinas, everybody working all the time to turn the ancient old beet hoppers between the beet dump at Camphora and the various sidings we stashed the full ones on for the night hauler that picked them up and took them as far as Santa Margarita. We were hauling so many beets that field workers were hitching rides south on them, so that some cars would talk to you as you walked past them in the night. "Hey man, this car going to L.A.?" I'd say, "Si, pero muy despacio" (very slowly). You could tell where you were in the district by the smells—vinegar, sour beer, rotting vegetables, human shit, chocolate, onions, cooked tomatoes, allspice, hot corn tortillas, fresh lumber.

We had been so busy that month that neither of us had been able to lay off to go to the funeral in Oakland for the engineer Big Mack, and as Kreiberg and I settled in on the second unit after setting our train, we gave him a final roll-by.

"I remember when I was working as a herder at Watsonville," Kreiberg said. "Mack was the only person I'd ever seen go by the tower at 40 miles per hour with a train full of loaded auto racks, throw it in dynamic, and when he stopped in front of the yard office you could walk in a straight line from the engine steps to the door. He was that good. The perfect stop. But then, Mack didn't like to walk. Remember that baseball cap that said, 'If lit-

tle girls are made of sugar and spice, how come they smell like tuna?' He had 'LOVE' and 'HATE' tattooed on his knuckles. And that big black cowboy hat he used to wear and all those gold earrings?"

I remembered Mack from a few freight runs out of Oakland to Watsonville, a big black man with a bald head, a gold tooth, and a gold earring—a fancy dresser with a soft voice that people paid attention to. You knew you were going to have a nice easy run if you worked with Mack. He took the time to cultivate the tower operators who controlled access in and out of terminals, and they answered him right back on the radio, with a politeness you never noticed until it dawned on you that this trip had been smooth, real smooth. Like Mack.

When I went over to Amtrak he was there too, running down the San Joaquin Valley to Bakersfield. He drove a Ford top-of-the-line custom van with wire wheels and running lights over the cab, spoilers, and a red candy-apple paint job. A black panther was airbrushed along the side, and his CB handle, "The Alley Cat," written on the back doors. The vehicle suited him. In the Super 8 motel the railroad put us up in, railroaders had their own section because of their need to sleep during the daytime and walk with their greasy boots on the carpets. I used to love to stay in Mack's habitual room because of his superb taste in pornographic reading material, which he kept stashed in the dresser drawer.

The one time I saw him even slightly ruffled was when I kidded him mildly about his van.

"I parked next to your van, Mack. You moonlighting as a fireman?"

"Say what about my van?" he said, his voice rising a half-step into the baritone range.

"Great van," I said. "It's a great van. I just have a little white truck. Hardly any truck at all, next to your van."

"Hmm," he said. "O.K."

When I heard about the accident, it was after I had left Amtrak and gone back to freight. The San Joaquin was the fastest track on the division and numerous rural road crossings would appear out of the tule fog only when the engine was right on top of them. On one of those crossings Mack's engine met a chocolate truck, a tanker full, poised on the tracks and big enough to crush the cab and kill Mack and his fireman, Mike Passarella, in the fiery wreck.

I found myself hating that driver, as I remembered the countless times cars had run around crossing gates to beat the train and occasionally tried to run me down as I stood in the road waving a lighted fusee. Even people driving Volkswagens seemed to feel immortal and above the law. But because of their weight, trains cannot stop for obstacles. The engineer would plug the train and then the forward motion would continue for a mile as you watched helplessly. I also found myself hating Amtrak—just on general principles. All the everyday pettiness seemed doubly reprehensible next to this grim iceberg waiting in every railroader's subconscious—that this work sometimes kills.

"I heard he jumped at seventy," Kreiberg said.

"No, that was someone else. Both he and the fireman were found in the cab."

"It would take a lot to kill Mack." Our engines rocked as the wheels went over an ancient bridge near Elkhorn Slough.

"Well, that's enough," Kreiberg said. "A requiem for an engineer."

Our hoghead that night was Chris Payne, a rogue in his own right, and after we made our turn at midnight and were coming home with the empties, we heard him on the radio with the night trick dispatcher who was green on the territory and wanting to hold us for Amtrak's Starlight.

"Can you make it?" the dispatcher's thin voice worried.

"Well, I've got five big jacks and they're all on the line," Chris replied.

And the signal went green.

We beat Amtrak into the junction by a good three minutes, and Bob and I were rocking and rolling around those curves in the second unit, in that free time of morning that belongs to us, the night workers, even the hobos gone to bed, only the moon and the watchdogs traversing the cold surface of the land, us outlaws tonight stealing time, Jesse Flores—the conductor, emerging pale as we put the ponies in the house at Salinas, Chris grinning, and us brakemen, eternal children, happily tying them down.

"We'll get these brakes for you, Chris."

"Fun ride," Chris said, "and I bet that Amtrak hoghead appreciated it, too."

It turned out that Amtrak did choose to memorialize Mack and his fireman by naming two control points—places that are marked so that train orders can refer to them—c.p. MACK and c.p. MICHAEL. I pass them every day working a local switcher out of San Jose.

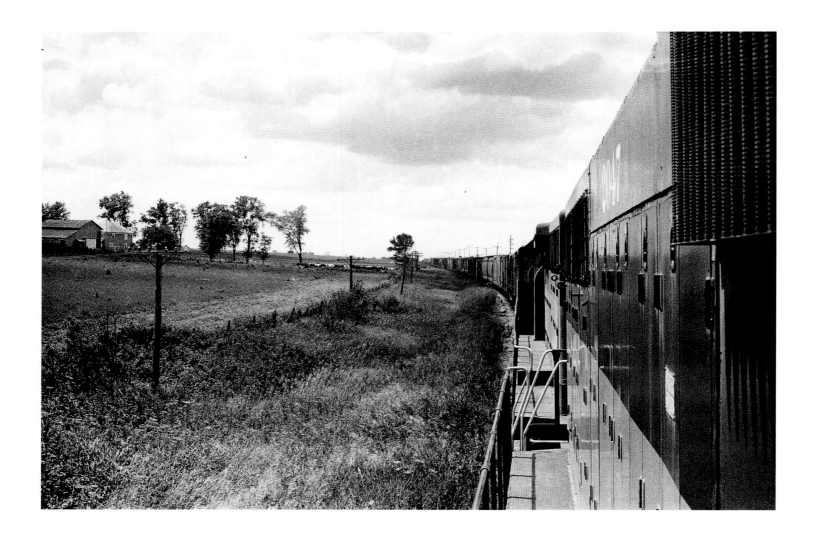

around the bend

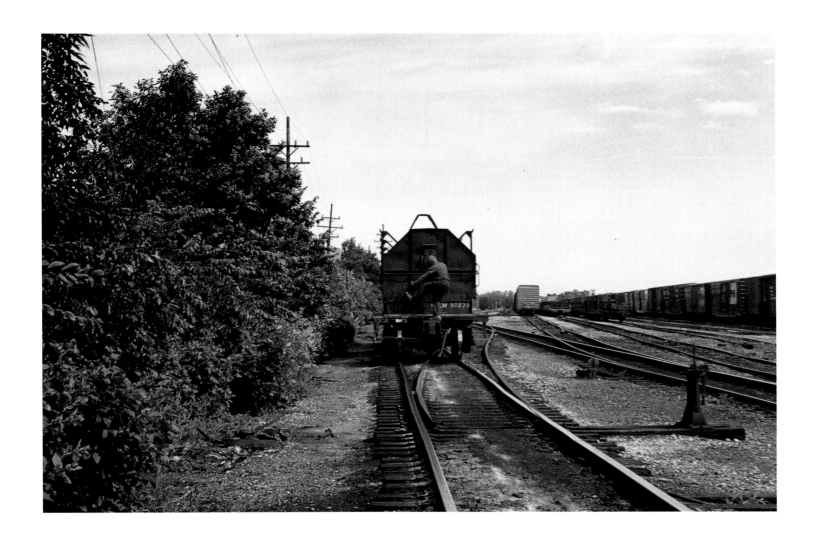

tying on a brake

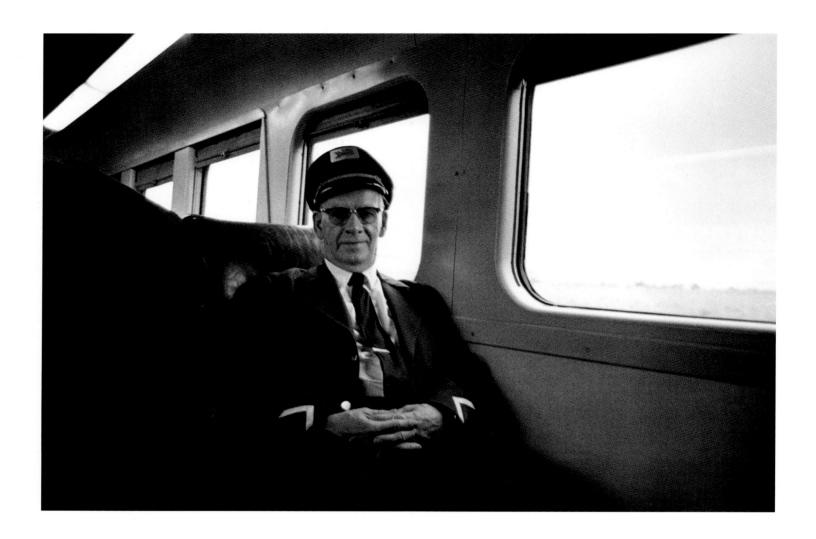

passenger train conductor

after lunch

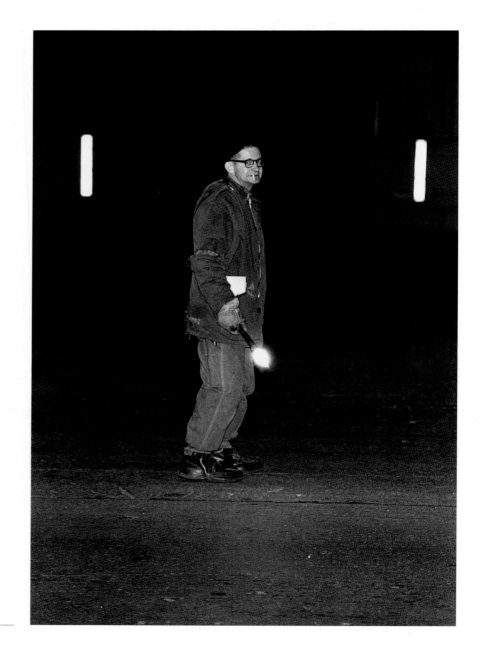

fusee

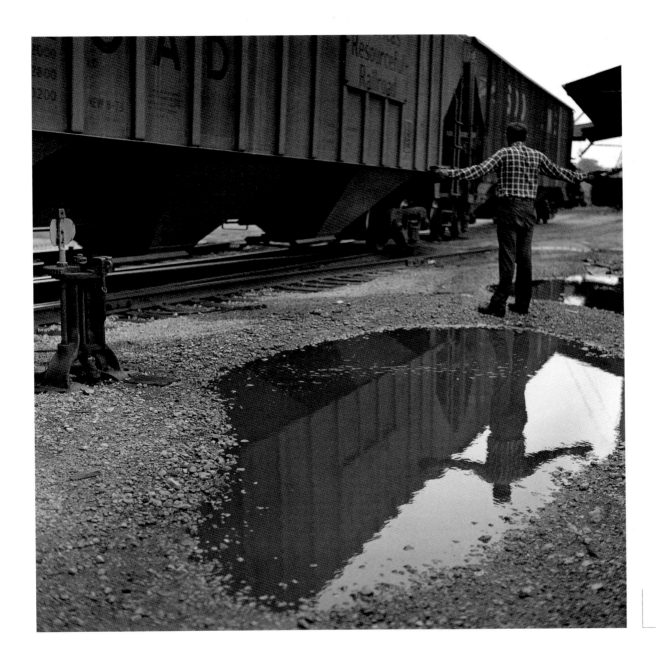

easy sign

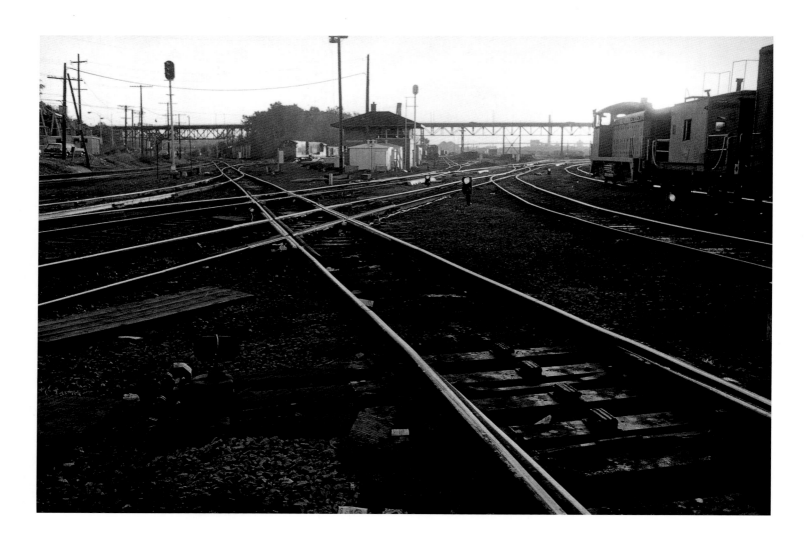

lineup

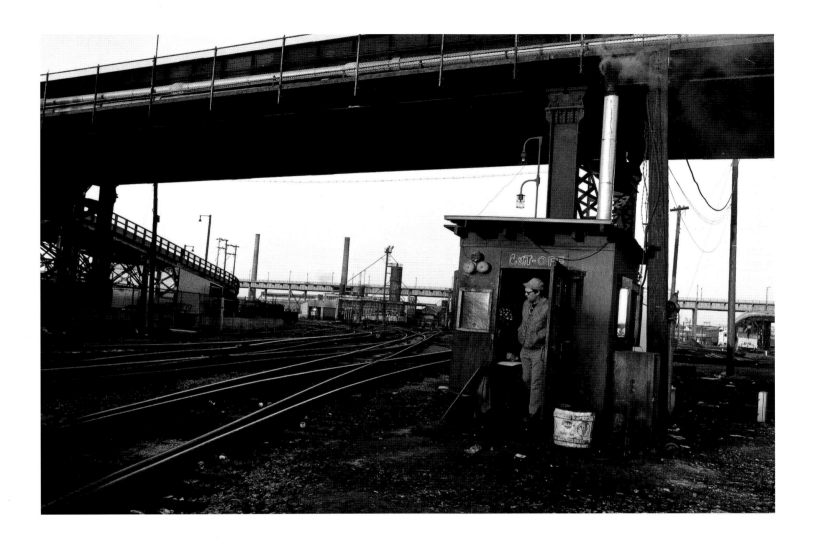

the cut-off

## Railroad People

I knew Josie Cole from L.A. in the seventies. She had hired on in 1978 as a switchman, then transferred to engine service. She had heard about me and I had heard about her, and when we met in a women's bar in Pasadena, I had the feeling we would be friends for life. And if Josie was your friend, you had one. She was a small woman from Louisiana, but her personal energy field was king-size. One time, after we had been drinking at an airport topless bar, Josie was rummaging through her purse for the keys to her Chevy truck. She pulled out a snub-nosed Smith and Wesson revolver and set it on the top of the cab. The truck's bumper sticker read, "With God, guts, and guns our freedom was won." At the time, the IRS was after her for joining the survivalist tax rebellion, and Josie eventually had to let them garnishee most of her paycheck. The tactic she initially used against sexual harassment in the yard was to do her job well and draw a line. If a harasser persisted, she stood up for herself.

In 1986 she took a buy-out from Southern Pacific. Like a lot of rails, she found civilian life difficult.

"When I took the buy-out I was in a relationship, and four months after I took the buy-out, my relationship broke up. I moved up to Crestline and tried to be a commercial photographer and lived on the money from the buy-out. I was there for a year and a half. Then I ran out of money and had to do

something, so I ended up back in L.A. working a stupid little job. I had my dog and my cat—Kelly and Odessa—and it's hard to find a place with a dog and a cat. I worked for the Super Shuttle as an airport driver, and I was rooming with someone but the money wasn't coming in good enough. I thought I could handle it, but it was bad judgment on my part. The first of the month would come around and I'd be another $400 in the hole before I got caught up on the first month. So I asked if I could start clean and she kicked me out. So I was out on the street, and I had my cat at someone else's place and I stayed at my ex's place for four days, but I couldn't stay there and I had nowhere to go. I was trying to find a place and I was basically no place. I was pretty messed up that night and I got in my car and I didn't know what direction to go. It was about three in the morning and my car headed east and I was all the way out to Pomona when I realized I was headed out to the desert. I was pretty upset—I even missed Highway 15 and ended up in that rest area out by Colton yard. It was five in the morning and me and my dog were in my little Honda CRX. In the morning I headed out to Barstow and there I was at my sister's five acres, where I had my trailer. A few days later I went back into town and got my cat. I thought, 'Well, I'm out here. At least I've got shelter and my dog and my cat.' Then I knew I needed to work because I had a car payment, and a half a mile away, off Interstate 15, was Jeremy's Gas and Market in Newberry Springs. I went to get something at the store and I said, 'You're not looking for help, are you?' She said, 'As a matter of fact, we are. Have you ever worked a cash register before?' And I said, 'No, but I used to be a keypunch operator and I'm fast and I'm accurate. I'm sure I can learn that little cash register machine.' I started at $3.25—minimum wage. After two weeks, she gave me a fifty-cent raise—retroactive, even. I worked the store, made sure the shelves were stocked, worked the closing, and mopped the floors. I did that for three months and while I was doing that I could see the Amtrak Desert Wind flying by. I would just look at it.

"One time when I was driving up Highway 395 right after I took the buy-out, I had an intuition that flew into my head and right back out—that one day I was going to be running passenger trains. Little did I know when I was working Jeremy's, watching the Desert Wind fly by. I had no idea I would be running it."

"With Bill Sheehy as conductor," I said. "That famous boomer."

"Yes, with Bill Sheehy. And Buck Cleveland, great-grandson of President Grover Cleveland, and engineer Gary Grimes. But this was in '89 and I was working at Jeremy's and I would watch that Desert Wind going by. I missed the railroad, and I had forgotten what my intuition had told me.

"I worked it for three months and I was a good employee, but when they raised the minimum wage to $4.25 so all the other employees automatically got a dollar raise, I thought I should get a dollar raise, too. But she said, 'I don't think so,' so I quit."

In 1989 Josie hired on Amtrak as an assistant conductor, and, six months later, swiched to assistant engineer. After three and a half years off, she had to learn her craft all over again. Running passenger was faster than freight, and she had to learn the rules and territory of the three different railroads that Amtrak ran over.

"I ran up against two engineers who gave me a hard time. I was their fireman and they wouldn't let me run. How do you learn if you can't run? Then, finally, when I did get a hold of the reins and I ran a good train, the Amtrak officials were almost shocked. But I'm a good engineer. And I am respected. Finally, after fifteen years, I have earned the respect of my employer and fellow workers. When I first went to Portland I didn't know anybody and I was afraid—I didn't know how these people would be. I worked past the couple of engineers that gave me a hard time and I've made a lot of friends on Amtrak. They're good people. Especially all the others that came over from different railroads—it was nice working with experienced rail people. It was like a family."

Life on the road can be exciting, but it also means being constantly on call, working strange hours, and spending many hours in motels away from home. It's hard enough in good times, but in 1993 Josie was diagnosed with breast cancer and, since Amtrak didn't have a disability policy for their workers, Josie had to work through her six-month radiation and chemotherapy treatment. To get her through her surgery, her fellow rails donated their own personal leave days to give her a month off. But after that, she was back on the rails.

"I was O.K. during the day," she told me, "but at night, when I was in that motel room and would wake up alone and turn on the light, I just fell apart. I was trying to quit smoking, too, but one night I woke up and my hair was coming out and I thought, 'Well, that's it.' I just had to have a cig-

arette, so I went across the street to a little convenience store where we used to go all the time and they knew we were rails. A black kid was working the cash register, and when I got in there, I just lost it, started bawling, saying I just had to have a cigarette and he just took care of me. He came around and hugged me and told me I was a tough lady and I was going to be all right."

"Was it hard keeping it together around all those macho guys?"

"No, as a matter of fact, an old head engineer—Larry Spring—got on my job just to take care of me. 'You just sit there,' he told me, 'and don't do nothing.' He stayed on my job for five weeks."

In 1994 Josie and I were both working in L.A. again. I was there on the Southern Pacific region-system board and Josie was trying to find a "home"—that's how railroaders refer to a little job you can live with. L.A. was the only place her seniority would allow her to hold a regular job, and, for engineers, moving means having to qualify on the new territory on your own dime. This means making student trips on every run in your new district with a company officer watching you. After her cancer treatment and during mine, we often talked about river trips and seeing Mexico together, but Josie had to use her vacation time to move and to qualify in L.A. She used another week of it to drive to Montana to visit her sick mother, her car breaking down en route. I knew she had to keep pushing, but I didn't have to imagine how much this continual effort was costing her. I knew.

Moving to L.A. also meant finding a new doctor to put her through all the checkups you are supposed to have after cancer. She would make an appointment with one listed near her in our managed care book, only to have him cancel and reschedule her. Anonymous doctors seeing new patients do not understand that a railroader's life is so erratic that to make an appointment you have to focus your entire week around that one date. You have to take two days off, losing two days' pay, to make sure you are in town at a certain time. As a result, Josie was missing a lot of routine exams. She was living in Glendale for a while, working the Desert Wind to Las Vegas. Then she qualified on the San Diegans and got a daylight run. Finally, she made a down payment on a little condo of her own in Oceanside. I went down there to visit her, and Josie and I and Cease Poxon, an L.A. hoghead, went out to lunch and walked along the waterfront. It was one of those perfect days. I had recovered from my breast cancer treatment, and Cease had just under-

gone major surgery on her arteries. We sat down on a bench with a view of the boats.

"We're all a bunch of wrecks," Josie said.

"But we're still chuggin'," said Cease.

A week later, Josie found a local doctor who ran her test. She found out her cancer was back. I think she had a month in her house by the sea, and then she was in motion again, this time carried along by her railroad friends, who packed her up and moved her back to Portland for treatment, where she had a doctor she trusted and a network of supportive friends. She was living on the railroad retirement sickness benefits, the grand sum of $500 a month. She lived with her friend Laiyne for a few months and then moved into a trailer in Blue River belonging to Coco—a Eugene hostler. In August, just before she went in for a bone marrow transplant, some of her friends gathered in Portland to celebrate her birthday. The party was held at the Portland railroad motel, conveniently just down the street from the hospital. My first thought when I saw the dingy room was, Why here? Why not a more posh place? But then the rails started to arrive, and the desk clerk knew Josie, and I realized this was the place she would be living during the two-month isolation period of recovery, when anyone's random germs could kill you. And the crêpe paper went up, and everyone was blowing up balloons, and food arrived—big bins of fried chicken and beer—and the room filled up with railroad stories and gifts of cash and Josie was surprised. Her wish to see her friends together in one place had been fulfilled. The party went on for twelve hours and carried over to the next day, as we walked around in the city, resting often, surrounded by clear white light and, inexplicably, all of us happy to be alive.

In September Josie went into hospital for a bone marrow transplant. After harvesting some of her own bone marrow stem cells, they gave her massive chemotherapy. They then reintroduced her stem cells, hoping they would re-produce enough to keep her alive. Her sister Kristie flew in from Montana to stay with her in the hospital during the procedure. It took Josie a long time to come back, and then, when she had to leave the hospital, she had to live in isolation for several months. It was fall in Portland, and Josie was staying at the railroad motel. Our phone conversations were about her daily triumphs—getting to the store on the corner, taking her dog Kelly for a walk. She was also angry with the doctors, the incomplete information, the

agents of death at work in the world. I knew Josie was not talking to me about everything because I was still waiting out my cancer, too, and she wanted to protect me. I would hear more about her struggles from her other friends. We started keeping in touch with each other on the Josie hotline.

In December Roseville hostler Coleen Hunt had a party and invited Josie's friends. People arrived from all directions and together they waited out the weekend before Josie's latest test results came in. It was bad news. From then on, the medical fight was over. She decided to spend her remaining time with her family, in Big Fork, Montana, where her sister managed a motel.

Josie told me about a conversation she had with a social worker there.

"She asked me if I had talked to the big man upstairs, and I told her that I believed in reincarnation, that life is a circle, and that we are born and begin the circle and are here on earth to learn. It's our school—to learn compassion and other things—and when we die, it completes the circle. I'm getting ready to become a space traveler."

In February I flew to Kalispell, gateway to Glacier National Park. Below us I could see the Southern Pacific tracks to Salt Lake City, where we changed to a smaller plane and flew north, above the route of Amtrak's Pioneer. Other tracks connected Kalispell to Seattle, runs that Josie had made. It was second nature to be aware of all of them—the map we lived upon now in black and white, and cold. Margaret, the former bartender from the place where I first met Josie, was already there. Craig Sharp, a Portland Amtrak engineer, was driving Josie's car in the following day. I knew Craig from my booming days. We had stayed in conductor Pat Doolette's house in San Luis Obispo one summer when I was bumped out of Watsonville. Josie had stayed with him in Vancouver for two months before this last move. There were many rivers coming together here. Josie was on a portable oxygen machine and popping Ativan and morphine pills, but she insisted on showing up around Big Fork. We pulled a few slots, ate lunch, and looked in the store windows at the fancy Santa Fe–style ranch clothes.

Back at the motel, Josie's hospice worker was having trouble understanding all the railroad lingo and the constant stream of friends. "Who's in charge of the train?" she asked us, calling up the age-old rivalry between conductor and engineer.

Josie and I looked at each other.

"The engineer is," she said.

"The conductor is," I said. "But today, the engineer's running it."

The next day Josie had some trouble getting outside in the snow to have her cigarette and told us that maybe she'd quit smoking now and get a wheelchair. She went on morphine drip the next day, and I said goodbye to her in the morning. Her family had gathered, and Cease and Laiyne flew in as I was leaving. Cease told me that Josie waited to die until Coco arrived later that night. I couldn't help thinking that she had run her own train until the end, like the person and engineer that she was.

A month later I got this note in the mail:

### Josie Cole

Sunday, March 16th, 1997, at 11:00 A.M. one hundred car-lengths south of Olympia Station, a memorial was held for the late Locomotive Engineer, Josie Cole, one of the best engineers to ever sit behind the throttle of a locomotive. As requested by a dear friend and a fellow engineer who was bedside when Josie pulled the pin, a portion of Josie's spirit was let go from the cab of a locomotive in motion.

Songs by harmonica included: "Wabash Cannonball," "I've Been Working on the Railroad," "Wabash X-over Blues," and "What a Friend We Have in Jesus." An announcement was also made from within the train to the General Public, followed with one verse of "What a Friend We Have in Jesus."

## Ghost Yards

I worked a lot in Salinas in the summer of 1991, a foggy summer during which the sun came out three times at sunset like a groundhog and then went back inside its grey tent. Later in the summer, right after the few hot days, a freak storm blew in and woke me up at midnight with thunder and an erasing curtain of rain.

That storm was the first time I had felt anything in months, perhaps all year; the rain slanting off the roof triggered dreams and I woke up crying and not rested from sleep. The next day on the news I heard three farm workers had been killed as they picked lettuce in the fields, struck by lightning, one man's lips burned so badly that other workers couldn't give him artificial respiration.

Their families in Mexico would receive three times what their wages were for that day, I suppose about a hundred-fifty dollars. California working-man's compensation.

Sometimes I wonder if living in houses is good for people, if it doesn't protect them from knowing anything, but I wouldn't want to be living in the fields either, or in a dug-out cave next to them with a cardboard bed and a freight yard for a neighborhood park.

I know about the cardboard beds because of where I work—the Salinas and Watsonville freight yards. When I first hired out here as a brakeman in

1979, the yard was a busy place during the summer, gathering up the perishable freight for the Peddlar coast train to pick up at 2:00 A.M. every day, hundreds of cars for us to switch out using hand signals in the particulate Watsonville fog, the bonus being strawberries as big as your fist right where you were standing to pass signs. Now the fields are better guarded and the yard has been encroached upon by people who are living there. Half the tracks have been pulled up, the yard office has a switch lock on the door, and three machines replace about twenty clerks who used to be like our family, the ones who stayed somewhere permanent while us trainmen spun out like yo-yos from our home terminal—when the term "home terminal" meant something. A brakeman might not have a home, but he had a home terminal. Now there's a fax machine, a copier, and a computer.

They pulled the yardmaster's tower over and didn't bother to haul it away, so it lies there in the yard like a huge insect on its side, the windows boarded up, with Mexican music coming from the inside. Men sit with their legs over the rails, drinking from bottles in paper bags, and women with shopping bags and three children holding on to their skirts dart between the cuts of cars as crews work the yard. You always wonder if you're going to kill some child or a drunk who might be between the cars. It happened in San Jose one morning, when a head rolled out onto the footpath after the brakeman gave the engineer a go-ahead to pull on the track full of cars to see if he had them all. There's not enough people around any more—car men or switchmen or brakemen walking the train or switching the yard or checking the tracks. And encroachment happens—the street scene moves into the empty spaces, people put sofas out in the yard and start using it as their living room.

I couldn't help thinking that it could be me living in a cardboard box underneath the abandoned tower. After all, most of my life has been spent in yards or tracks like these, now filled with homeless camps and shooting galleries. You had to watch out for the used hypodermics littering the yard, and for drugged-out people, often teenage girls, who would sit down on the rails or stand between them swaying. Getting off a train to line a switch, I had to ask three people waiting for a shot to move out of the way. The engineer told me when I got back on the engine, "I was watching you and if any of those guys came at you, I was going to shoot 'em in the ass."

Not too long after that an old head conductor got his throat slashed in the Salinas yard when he confronted a trespasser—a clear sign that the old

balance had shifted. It used to be that hobos kept a low profile and switchmen were in control of the yard. Now the yard is becoming a public space that no one wants to police. The city won't control it because it's railroad property, and the railroad won't do it either.

"Why, you're a lady!" a man staggering down the track said to me recently. "You could get killed out here."

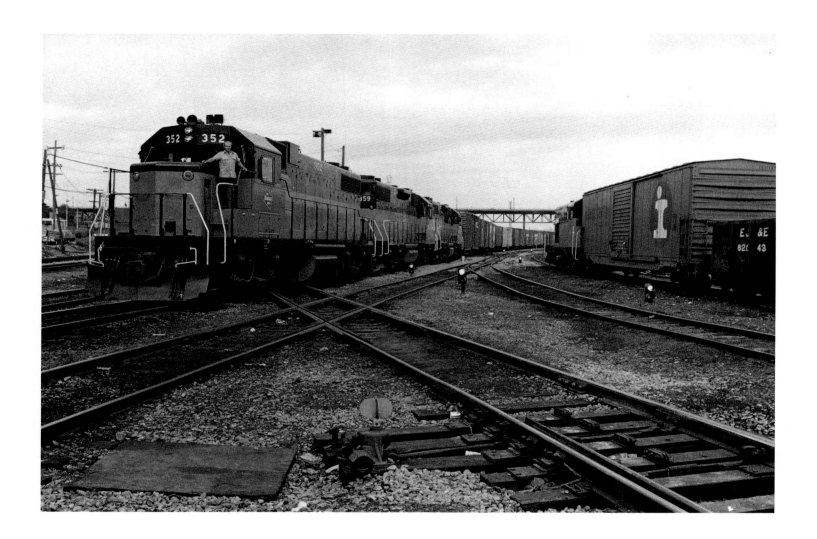

**main-line train**

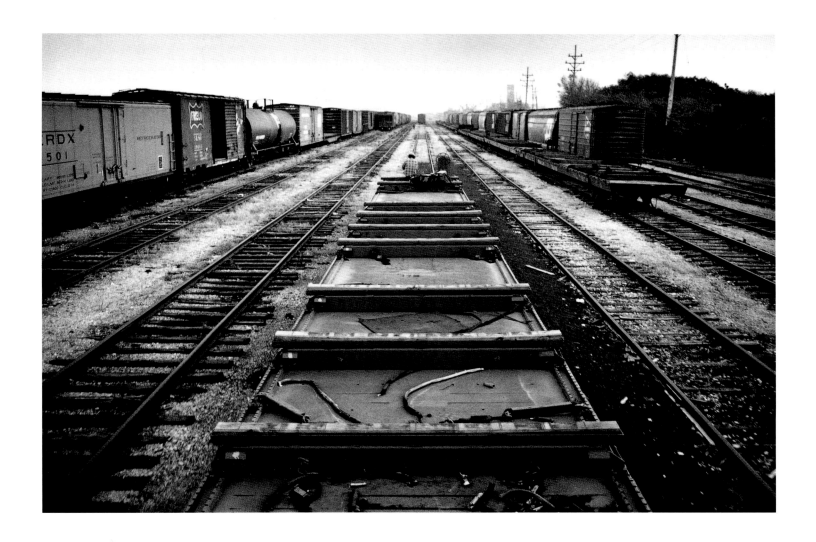

tying together

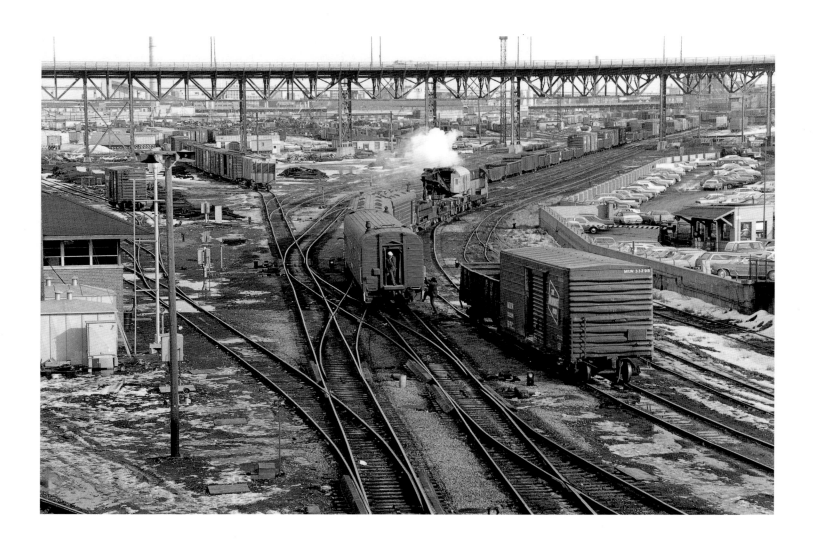

**down the lead**

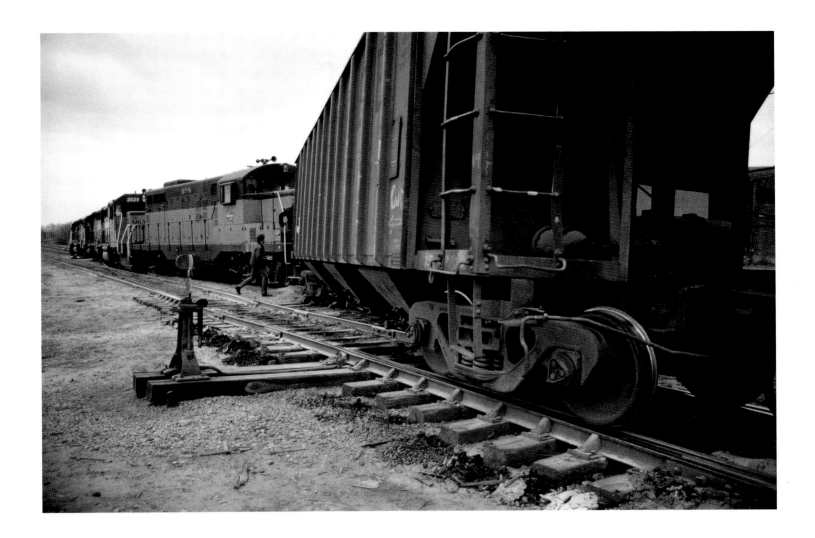

derailment

calling signals

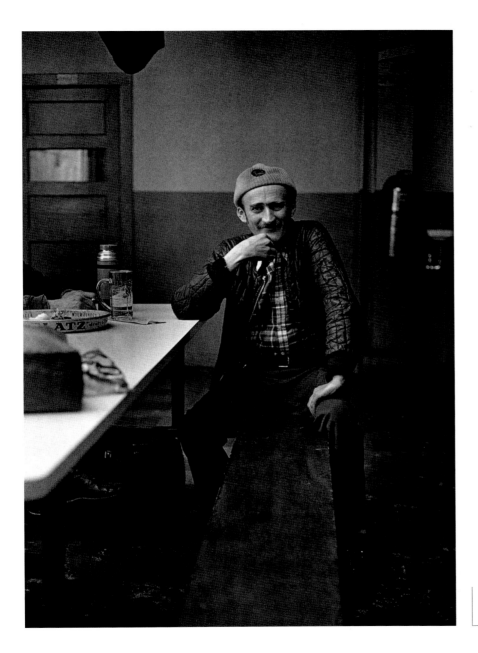

lunchtime

## The Good Shepherd

The night of the earthquake of '89 I slept in the back of my truck in the San Jose freight yard. Our crew had been held out in the Redwood City yard with nobody answering us on the radio until the track was checked and all the commute trains limped in at ten miles an hour past us on the main line. I had been down on my knees between the engine and a tanker car loaded with alcohol hooking up the air hoses when the tanker started to dance and the booze started sloshing around like the surf at Santa Cruz, where I lived. I didn't put it together, though, and kept trying to make the air hoses meet, although now it was like I was milking a cow.

"Hey," the engineer yelled, as he sprinted past me, "get the hell out of there, she's going over."

It was a calm and silver-edged October day. Only the grass trampolined as we moonwalked and the liquor warehouse doors banged open and shut—the only incongruous sounds. It was good to be outside. Only when the drunken moment passed did we realize that disasters had happened around us. Traffic lights did not resume and for once a totally natural sunset darkened Silicon Valley. We waited in the little switching yard for our turn to go home, along with the normal residents—junkies and winos who had their couches and bottles strewn throughout the tracks—their neighborhood park.

Gathered with our lanterns in a circle, we felt their bodies around us, moving in the dark. About 2:00 A.M. the dispatcher answered us on the radio and we crept back to the terminal. It was an hour over the mountains to get home. On the road, though, the highway patrol turned me back because the pass was destroyed. I soon discovered all the motels were full, but I knew I'd be safe in the freight yard. And so I went back, parking my truck next to the roundhouse where there were lights on all night. After ten years of railroading, it felt like my home. And that fact seemed even sadder than the earthquake and the wreckage all around me.

I had come from a middle-class home. My father was a scientist professor and my mother didn't work. She was, as I recall, afraid to drive alone after dark. My boat was floating on a lake in a country far beyond their imaginations, and sometimes I felt completely adrift realizing that even if they had not been dead, I would not have been able to reach them across a distance so severe. I could not have called home, even if I had one and the phone lines weren't destroyed.

My parents lived in a Spanish-style Pasadena house of such immobility that in the eighteen years I lived there the furniture was never moved or changed. Crawling on the rug as a child I would find grooves where the legs of a coffee table had made indelible footprints. The furniture was not particularly good, but it was fixed, like my parents themselves. In this fortress of solidity I also grew up knowing that I didn't belong there and that I could not inherit this type of endurance. I never fit into it, and it remained in my memory as something that had excluded me.

When I could choose, I lived in nests, tree houses, old houses almost falling down, and rooms painted violet with midnight-blue floors. One time I dreamed of a room on a cliff overlooking the sea. It had three concrete walls and no roof, one wall painted a fluorescent lime green. I couldn't have furniture—couches, in particular, terrified me. They were lifelong commitments.

My own attempt at a home had not gone well. I bought a redwood cabin on top of a mountain; the structure hung from two redwood trees with rubber tires nailed around their trunks. The place was too remote and the road too bad for me to take those 2:00 A.M. railroad calls, and normal renters couldn't handle either the road or the dog packs. I finally sold it.

Home was an improvisation after that. I bought furniture and a kitten so that I couldn't move around. I rented a house and stayed there eight years,

while my friends kept asking for my new address. "The same," I'd say. "Oh, really?" they'd say, not believing me.

To stay in my home, I drove to Oakland to catch my trains, three days a week. I worked the San Francisco extra board on call, an hour and a half from where I lived. I had just that much time to respond to a call. I'd wake up at the wheel, many times—on the road five minutes after the crew dispatcher's voice awakened me.

"Niemann, 4:30 train number twenty-eight on duty San Francisco."

Just to have a home—although it really resembled a department store showroom, featuring empty rooms populated by a Himalayan cat, an immaculate leather couch, and a lacquer dinner table seating ten. The storefront space simulating the perfect Pasadena home, a replica, hanging in space.

After the earthquake, with the chimneys repaired and new bowls in the cabinets, I tried to stick closer to my house and cat in Santa Cruz, and worked the locals around Watsonville. But it happened that I needed a predictable life for a while to promote a book, and local freight kept me on call and unable to make promises. And so, once again, I found myself working in San Jose, this time on passenger trains running up the peninsula to San Francisco.

The only regular job I could hold on the commutes as a brakeman worked the least time on the rails, paid the least money, and had the worst schedule on the roster. Every weekend we worked the midnight train from the city to San Jose, then the ten o'clock back up and the midnight back down. Sunday was a double—four trains from 10:00 A.M. until 9:00 P.M. We didn't arrive back in San Jose until 1:30 in the morning Saturday and Sunday, and it was an eight-hour turnaround to be back to work—tight even if you lived in San Jose, but I lived in Santa Cruz, forty-five minutes away. Add to that a twelve-hour layover in San Francisco with no way to get around and no place to stay other than the old-head locker room at the depot. Every weekend. One of those real plums.

I thought about the homeless people who were locked out of the shelters during the daytime. There we both were, wandering the streets, my time as aimless as theirs unless I became a shopper with some destination, or a golfer, as some of my fellow brakemen were, getting off their trains with bags of clubs, ready for a day on the green. By the end of the week, I felt the

presence of the street people like a contamination, and I was relieved to be home in a suburb to wash them off with a hot shower.

I had been crashing on the conductor's floor during our workweek to get more than five hours' sleep, but one night at five minutes to midnight, as I was all set to highball the last commute train out of San Francisco, Larry informed me that a new roommate was moving in.

"Tonight?" I said, wounded that he would drop this on me in such a casual way. It meant that I would be spending the night in the parking lot, chez truck. A year since the earthquake and still the same old room with a view.

One of the women coach cleaners saw me crawling out of it in the morning, though, and offered me a step up—sleeping space on the floor of the coach cleaners' shanty perched three feet from one rail in the San Jose yard. The depot itself was full of people sleeping under the pedestrian tunnels and even in the yard itself. Hard to believe, but one rainy day one of them had rigged up a tent to one of the switch stands and was sleeping between the rails. The locks on the doors were nothing wonderful, and I didn't feel safe sleeping upstairs in the "blue room," where conductors could crash between trains and in the old days sleep overnight. Anybody with a coach key could open those locks and a lot of the street people were mental cases.

The women's side of the coach cleaners' shanty was tidy and had a few little touches of home. A coffee pot, pictures, a latch on the door—I could set up my cot in there, unroll a sleeping bag, and be asleep by 2:00 A.M. The main-line trains rolled through all night, shaking the place, but that was nothing new. In the morning, when the coach cleaner next door didn't make too much noise, I slept until 9:00, had a cup of coffee, put on a clean shirt, and was on the train by a quarter to.

We used the same train equipment as the night before, and the best case was if a drunk hadn't let go all over the upholstery on the ride down. The coach cleaners in San Jose only swept the train. Mopping was a specialized task performed in San Francisco, and so, like a hangover on wheels or the lost memories of our more inebriated riders, all the pieces of the puzzle remained in place, pretty picture or no.

"Inconsiderate of us to be riding through their living room," the helper conductor remarked as one of the transient needle freaks living in the west end of the yard urinated on a switch stand as we were leaving.

"One of them peed on the bicycle rack last night," I said. "I mean, all

over all the bicycles. There were also turds in the tunnels. O.K., that I can understand. But why on the bicycles?"

I was feeling especially intolerant today, thanks to a long chain of unauthorized peeing. It started Friday night on the drunk train when first off somebody threw up between the cars, all over the hand brake handle, all over the door handles. And who has to tighten that hand brake? I do. Who has to walk through the train? I do. So I'm staying back in the last car, hoping the conductor will have to go forward first and clean off the handles. And I'm at the San Mateo depot ready to highball the engineer so we can leave and I see this water jet arcing out from the next set of doors. I couldn't believe it. Some guy is standing in the doorway peeing out the door. Now am I going to close the doors on him? I don't think so. Because who has to stand in that doorway all day tomorrow? I do.

"Last Sunday," I said, "I walked up to the train to do an air test, and I found this guy peeing on the train. It was the last straw. I walked up to him, still peeing, and I told him to stop. I told him that I personally had to reach under that train and open air valves. I could see he was shocked, but after all he wasn't peeing against a tree in the woods somewhere."

"Maybe he was," the helper conductor said dreamily.

Now I know there are other people on the train besides nut cases and drunks who have lost control of their bodily functions. The problem is I can't see them when an antagonist is within range. I let the one bad apple get to me. This interesting characteristic of mine was making my life miserable. Why couldn't I have a duck's back and not velcro? Why did I care what some idiot thought of women-in-general, or "women doing a man's job," or the fact that I didn't look like "a happy camper" at 1:30 in the morning? Why couldn't I hear the soft voice that said, "Thank you for getting me home safe"—the reward of the good shepherd?

"Well," my friend Linda suggested, "you might remember what Walt Whitman said about there not being any occupation so humble that it could not lead to enlightenment."

"What about the guy who stabbed the nun with a ballpoint pen at Sunnyvale?" I said. "It happened in the vestibule. When she got off the train she had a pen sticking out of her neck."

"That's there, too," Linda said.

It was the word "humble" that stuck with me as I inspected the train, an-

nounced the stops, opened the doors, and made sure the passengers got on and off safely. It was a good thing to do, to get people where they needed to go. It wasn't bad karma in the bank in any way and yet something about it rankled me. I didn't have the illusion of power—personal or otherwise. It wasn't my train. The rules weren't my rules. I wasn't even wearing my own clothes. Humility. That was it. I didn't have any. It was hard for me to visualize myself as some incognito genius doing passenger work as I could with freight. And when I reached the limit of my personal endurance—which I did every Sunday during the ten-hour day—it was humiliating to me that I was too exhausted to keep up my defenses with the passengers. They could get to me. I felt like a bear at the stake. Unable to change my basic position, I took refuge in fantasies of superiority. "I am better than this," I thought. "I am better than this kind of work."

Working on freight I never had these thoughts, but service work was hard for me. I used to admire how the train attendants could keep their composure and extract a tip from the most difficult passenger. I tried to emulate them and failed. I was too used to having my way.

Was enlightenment kind of like an airlift that could move you several places on the board at once, or did you have to get the first moves on your own? I wondered. Only an airlift was likely to move me.

Instead a minotaur arrived in the form of a fat man—a Friday-night-regular who got on at Menlo Park and off at Lawrence, and always with a drunken energy that needed to engage, needed to send verbal arrows flying out from the unwieldy center, too large, in fact for seats, and so he seated himself between the cars in the vestibule where I worked, sometimes holding onto a pole, sometimes sinking down on the steps, but always talking.

"I know," he said, "your father must have worked for the railroad. That's it, isn't it? And you think it's great to have that little lantern."

"No, actually, my father was a chemist," I said, hitting the door button.

"Well, why are you doing this job then?" he said, glinting up at me from the vestibule floor. "You can't find it satisfying."

"I find paying the rent satisfying," I said coldly, wishing that I believed it. The fat man was mind-reading.

"Oh, " he said nastily. "I thought you had more than that. I'm sorry."

"Look," I said. "I'm going to the other car to work the doors. Why don't you stay in this one?"

At Lawrence I saw him lurch off and wobble toward the parking lot.

"At least I don't get dead drunk every Friday night," I thought. "At least I don't weigh eight hundred pounds." But there was the ghost of the person who did living inside me. I had been a drunk just like the fat man. And had spent many years in a similar careen, probably under gazes like mine.

"Madame Bovary, c'est moi," I thought guiltily.

The conductor always left the train with the last passengers at the end of the line. I had to tie two hand brakes on the equipment and so I tried to time it so that I finished before they cut the engine off and all the lights went out. Some of the drunks were going to sleep on the train and it would be probably better for them if they did, but I didn't want to be alone with them in the dark while I finished up.

Then I climbed the stairs to the locker room and got my sleeping gear out of my locker and settled down in the shanty. I was too tired to think about the fat man but the night had other plans, his voice now collapsing into all those harrying voices I had heard all my life, warning me about failure while all the while I knew I could never be the way they wanted, never. "It's a man's world," my mother would tell me, broadcasting anxiety that I might turn out to be gay, that I might not marry well, that I might have to support myself in a world hostile to who I was, that I might turn out to be myself, working as I was, on this midnight train. "Fuckhead," I woke up saying, "Shithead. Who the hell do you think you are?"

Saturday was not going to be a stellar day. The whole weekend, in fact, I raged against my opponent, the voice that had come out of my mind and spoken to me on the train. "How dare he," I thought, "penetrate my disguise?" Rested by the week, however, I waited for Friday night. This guy would now feel attitude, a word popular with passengers demanding their rights. I would make him feel that he was superfluous, that he was inappropriate for the rules. Seats were for passengers to sit in, not vestibules. I would use a psychological version of the standard strategy to clear the lounge after last call—I'd freeze him out. "Frosty the fatman," I thought, "Igloo face, icebreath, you're mine."

He got on, demoniac as usual, at Menlo Park. Bantering with some young rich kids in punky clothes, ready to take me on. In fact, I could tell he was looking forward to it.

"Miss Conductorette," he said. "And how's the transportation business

tonight? Any stray chances to improve your mind, any interesting places to go or people to meet? Do you ever just think I'll take this train tonight to Bourbon Street instead of San Jose? You know, a highjack?"

"I had a friend do that," I said, "in Clifton, where the miners were on strike. Took two girls in a bar on a little ride. The miners dropped a dime on him. It's a finky world," I said, staring right between his beady eyes.

I froze him out, became busy in the other cars. He followed me lumberingly down the aisle, needing contact, maybe a continuity with the week before, maybe only a landmark to steer by.

"You don't like me, do you?" he said, trying to balance as the train hit the joints and rocked its rock. Something had shifted, and I had more power this time. He was more aware of what was frail about himself, and he clearly wanted something from me.

"That's right," I said, fixing his eyes, "I don't."

He looked away and then said in a softer voice. "That's all right. At least you're not indifferent."

"I'll tell you what," I said. "You just stay in your car, and I'll just stay in mine." He shuffled past me toward the head of the train.

"Sobriety has its points," I thought. You can watch and wait.

I opened the doors at the Sunnyvale stop and let two late-night office workers off and two stranded party-goers on who were running for the train. Collapsed in the seats and not sparring himself awake in the vestibule, I knew the guy was going to sleep through his stop. Am I my brother's keeper? I heard myself say. I knew I was. Am I a babysitter? I said. That made it more modern. In the modern world you have to watch for your own stops.

"Lawrence," I announced loudly on the intercom. "Lawrence station next."

I opened the rear door and stepped out on the platform, watching the two doors up the train. No fat man emerged. I waited a few more minutes, just to be sure.

"Highball," I signaled the engineer, with my little lantern. It felt sweet.

Tying down the brakes in San Jose I thought about the man on the train. "It's his wake-up call," I thought. I could be doing him a favor, but it didn't feel like that. And maybe he did me one, holding the mirror to my doubts and fears. I don't know. But Friday, at Menlo Park, he wasn't there, and so I couldn't know if he got home safe, or if he got enlightened, or if he just got lost and found another train to ride.

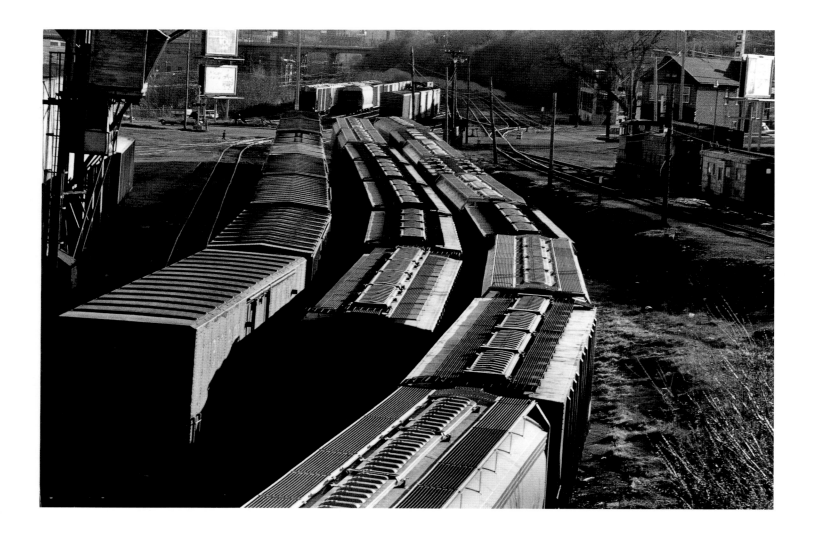

local switch trains

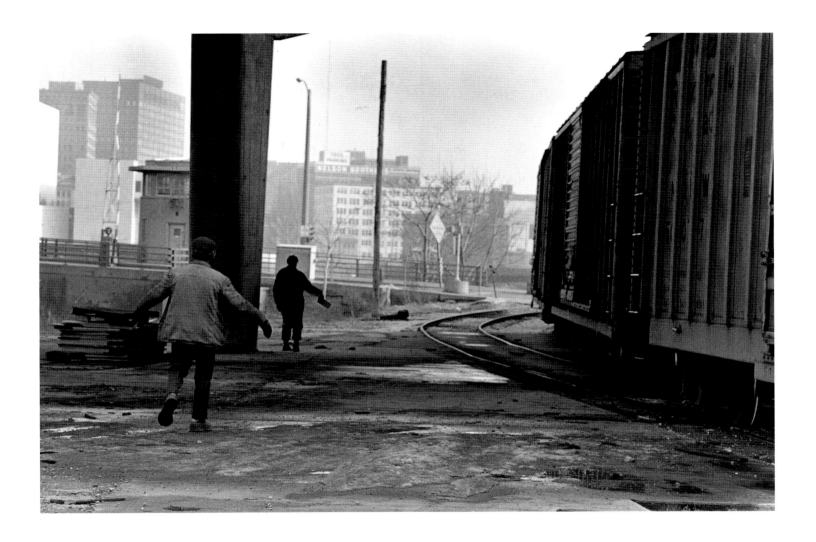

passing signals

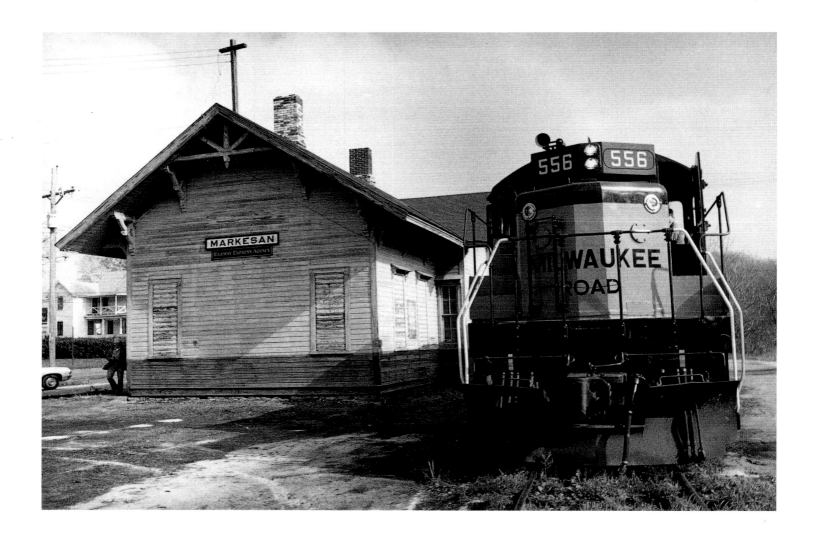

**branch-line station**

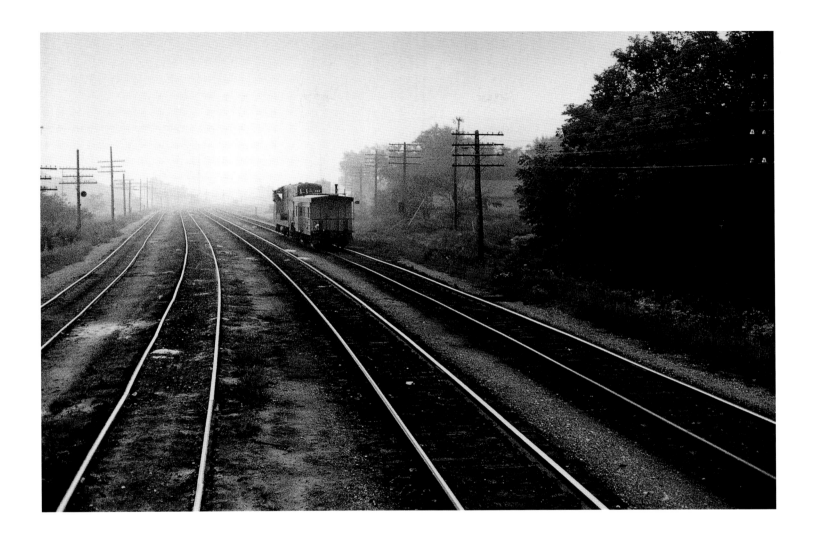

caboose hop

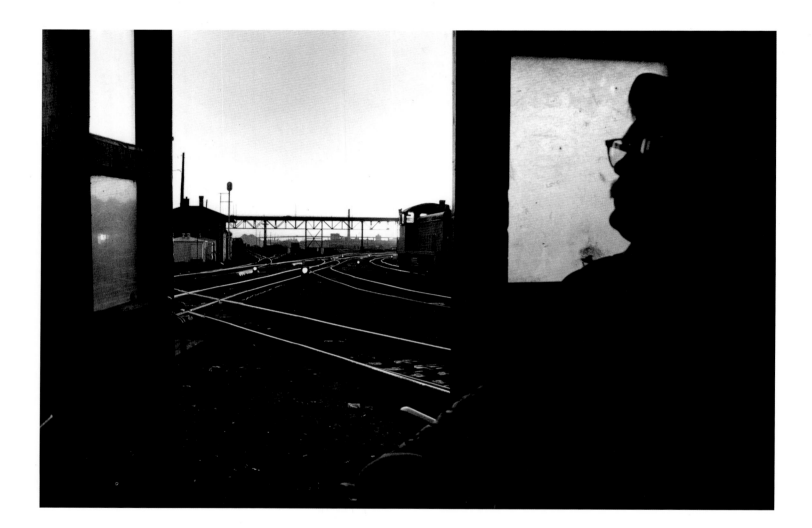

**dawn**

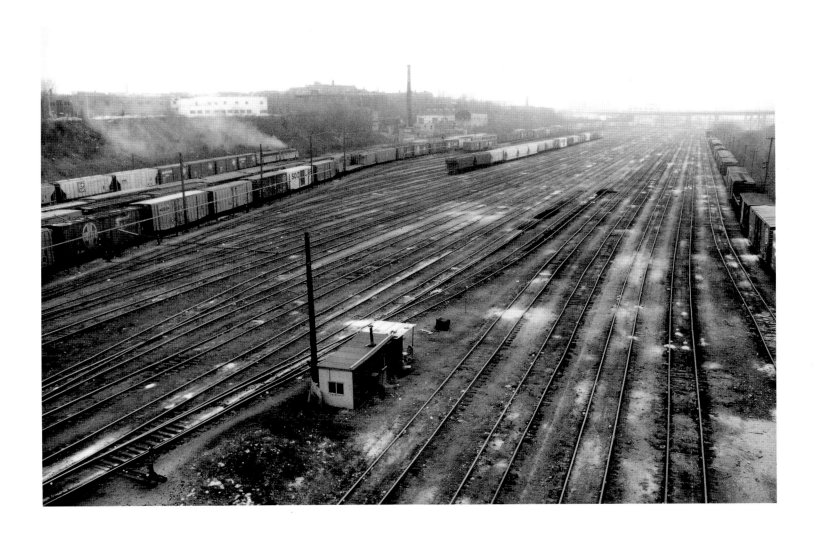

**outbound yard**

## River of Rails

El Paso in March, the weather loco, one night a deluge, the next day an oven, the spring winds sandblasting the green border-patrol Broncos parked every hundred yards, facing the Rio Grande. I work the river job with John Molinar and Tony Muñoz. I am so sleepy after five days of overtime shifts I can hardly stay on my chair. The foreman remembers ten years ago when I worked the river job, got covered with molasses while coupling up cars, doused the agent, too, who was standing next to me. They are still laughing about it down here. The desert preserves its histories. I remember the river differently then, when it was full of Mexican children using the sluice gates on the American side as their water slide, mocking us, playing tag through the many holes in the cyclone fence, groups of workers running through, an occasional green Bronco chasing them. Now are the days of "Operation Gatekeeper," the parked Broncos, the bleary-eyed immigration officers watching the river, smoking cigarettes, alone in their cars for an eight-hour shift. They are glad to see us, glad to have someone to talk to.

The El Paso yard itself deboned of half its tracks.

"Us switchmen told them not to take those tracks out, but they had a plan. You know you can't tell those officers anything. Now we can't hardly do any switching in the main yard at all, can't get around it without the tower's permission since they took out most of the crossovers. So these jobs

are awful easy now, since we spend all our time waiting. We do all our switching now out at Alfalfa. They laid that yard out so that you have to triple switch every cut. Takes about three hours to switch out a track. But then, you know that if you worked out there. But, like I said, you can't tell officers anything."

Working the main yard was slow motion indeed. It lay under the downtown so that you had a view of what skyscrapers El Paso could muster, along with the floodlit star on the side of the Franklin mountains that overlooked the city.

"They put that thing in for Christmas and just left it there," Ruben Tapia told me. "I don't like it. It gets in the way of the real stars."

We were mostly making long shoves with flatcars ahead of the engine into the yard, after which we would get ahold of another track and pull it out to the interlocking signals controlled by the tower and wait for a green. Then another long, slow shove back into the yard. I was riding on the point at the end of the cut, standing in the middle of intermodal flatcars as slow-moving trains passed me on the main line, going east and west from Tucson to Houston and north to Tucumcari over the old Rock Island line. It was a moonlit night and all the cars were moving in slow silvery motion like barges on the river of rails, so close to the border river itself that I felt like a boatman, riding there.

El Paso—river town, border town, the pass to the North, the crossing of the river Jordan to the promised land, now, for Mexico's dispossessed. A city divided, El Paso/Juarez, each side considering the other a bastard brother. I feel its psychic pull—bringing up secrets, images, desires, other languages, the idea of border itself—that by crossing a line one can move to the other side. *El otro lado*. Of the moon? From life into death? From death into desire. Beyond the borders of the self.

And here, on this windy March night, clouds floating, I think about someone I loved here—the trickster spirit of this place, and on the map of arriving trains I find him on a Kansas City trailer train out of Tucumcari at 7:15, due in at 4:00 A.M. I could be switching cars then, or at the river with a drag, the trains stacked up like hovering planes, waiting to enter the yard. We work the arrivals, reducing them, and I can't help imposing a scene upon the moving canvas, the slow river of freight clanging and creaking, entering and leaving the yards. We go to the repair tracks at 3:30 to set out cars, and

I can see a line of trailers moving on the main line west. It should be his train, and I can't keep quiet inside my skin, say "How about beans?" to the foreman as we put the pony under the bridge and take our break.

I know he will be sitting at the table even before I walk in the door and see him. Surprise, pleasantries, gruffness, formal salutations. I circle the room. He turns to his time slips. I sit on the bench, let time go by. He circles the room, energy flying, levitating the bench, like a dust devil sitting down beside me, words hooking me in.

"And so, really, why are you here? Why did you come back?"

"To see my friends," I said, leaving it at that, feeling suddenly the shaman's tariff—an open heart.

"Why are you smiling?" he said, teasing me, knowing full well. And gathering up his bundle of gifts, the morning star rose and drove east out of the city still ghostly with night.

"Do you think they know how much we make? When they see us coming into the hotel like this, all dirty at seven in the morning, they probably think, 'Oh, those poor circus people.'"

*Robert Coyne, Southern Pacific brakeman*

Fifteen minutes after I checked into the Los Angeles hotel, the Ramada Inn Burbank, a declining establishment whose only claim to fame was proximity to the airport and a fake Hawaiian decor, I was angry, and I stayed that way the entire twenty days I worked down there. It was nominally about not having a refrigerator in my room after being promised one on the phone the day before; but, really, it was about being here in smoggy L.A. after driving from El Paso to Santa Fe the week before.

You think about death in L.A., death and robbery and self-defense and looking good. Hot cars and hip clothes and lots of money without which you are nowhere, or rather, you are in all the places the railroad runs, graffiti-covered places with gunshots on Saturday nights and characters out of a Dickens underworld living beside the tracks in "crack alley" in Long Beach, warming their hands over trash-can fires and pushing bundle-laden shopping carts down the right-of-way at midnight. The danger of the train attracts

them and they dance in front of our engine, daring death, and making ob-
scene gestures before lurching away just in time. And after twelve hours of
surfing the underworld on trains that go nowhere, I could come back to this
hotel with its closed-up restaurant and its empty vending machines and its
ice machines that didn't work and its van drivers that make thirty-five dollars
a day and its desk clerks that couldn't take a message in English and its hot
water pipes that burst in your room and its maids who couldn't read the "DO
NOT DISTURB" sign you put on your door after working all night.

I just stayed mad, that's all, and decided to see what life was like if I just
passed being mad on to other people instead of being mature and forgiving
them.

One night I caught a run from Colton to Long Beach with an old head en-
gineer of the Midwestern true-grit persuasion. A man of few words, he didn't
waste any of them complaining about the many engine changes, the long
waits at the traffic snarls, or the myriad things that weren't right with our
train. He just doggedly advanced over the territory to yard our train within
the last five minutes allowable under the Hours of Service. Only to find, as
we sat at ten in the morning in Long Beach waiting an hour for our ride, that
the dispatcher who assured us at eight that our ride was on its way had
erred. Under the new F.R.A. ruling, we were technically in violation of the
Hours of Service Act. The company was supposed to have us in a taxi on
our way back to Taylor yard.

At this the engineer finally allowed himself to get mad, and I seized the
chance to go along for the ride. We were writing postcards to the F.R.A. We
were claiming violations on the federal log. We were calling yardmasters.

And the next day I was still involved in tracking it down. Who had made
the unfulfilled promise? Was it yardmaster so-and-so or the carryall dis-
patchers as he claimed? At a certain point, the yardmaster on duty just
touched my shoulder as if we were friends.

"Hey," he said, "let it go. You made your point. Now forgive. We all
make mistakes out here."

And all that rage I had been holding all month, the loneliness, the being
lost all the time, the coldness of the hotel, the desperation I had seen around
me—it all fell away.

Set against such maledictions the power of one good word held sway.

*Absolute signal*  A signal that directs main-line traffic, controlled by the train dispatcher.

*Air*  An air-brake system that consists of a compressor on the engine, brake pipes running beneath the cars, and flexible rubber hoses ("rubber") fastened together between the cars. When cars separate, the hoses uncouple, creating a rupture in the system that causes the brakes to set up.

*Bad order*  Bad orders are cars in need of repair. The term is extrapolated to mean anything defective.

*Beans*  Meal period.

*Big hole*  An emergency application of the air brakes that reduces the air pressure in the brake pipe and causes the brakes to apply. It makes a distinctive sound like a giant tire being popped.

*Big jack*  A road engine—that is, an engine with sufficient horsepower to pull a lot of weight. Smaller switch engines are used in yard work.

*Bleed a car*  To drain the air from a car's reservoir by pulling a rod located on the side of the car. Bleeding removes the air brakes, but not the hand brakes, and allows the car to roll freely.

*Block*  A designated section of track controlled by signals. "Blocking a train" also refers to arranging groups of cars in a train according to their destination.

*Boomer*  A railroader who travels to cities or areas where work is plentiful, in search of jobs.

*Brakeman*   In the old days, the brakeman used to stop the train by turning the brakewheel by hand. Once trains were equipped with air brakes the title remained, but the job acquired a broader purpose. Now brakemen do the physical work on the ground associated with switching out cars—throwing switches and coupling cars together, as well as securing cars left on a track by means of the hand brakes.

*Buckle up*   See *Couple up*

*Bump*   The displacement of one worker by another who has more seniority.

*Buy-out*   Severance pay.

*Caboose hop*   A train consisting of engine and caboose only.

*Call button*   The button on the engine's radio that is used to call the dispatcher.

*Check the list*   To compare the computer printout of the cars supposed to be on a track against the cars actually on the track. The train list is a computer printout of all the cars in the train.

*Chief*   The person in charge of on-board services on Amtrak. The chief shares authority with the conductor, not always gracefully.

*Clear alley*   A track with no cars on it.

*Color*   Usually refers to a signal that is a color other than green—namely, either yellow or red. To "see a color" means that your train has to slow down.

*Commutes*   Commuter trains.

*Conductor*   The straw boss of the train. The conductor is responsible for doing all the paperwork involved in reporting the work that's been done, getting the operating orders for the train, and assigning tasks to members of the train crew. He or she is like the captain of a ship: if anything goes wrong, the conductor always gets fired first.

*Couple up*   To attach cars by aligning their coupling devices and then moving one of the cars until the two hook together.

*C.T.C.*   Centralized Traffic Control—a signal and switch system, controlled by a dispatcher, that is used to authorize main-line train traffic.

*Cut*   A specified number of cars.

*Cut lever*   The uncoupling lever, located on the side of the car, that raises the coupling pin, allowing cars to separate.

*Cut off*   To be laid off temporarily; of cars: to separate.

*Dark signal*   A signal with a burned-out light. The rules require that such a signal be regarded as indicating a mandatory stop.

*Deadhead*   To travel to and from an on-duty point. One can refer to persons "deadheading" to and fro.

*Derail*   A switch that functions to derail rolling equipment, usually located near the fouling point on a track.

*Die on the law*   To work to the limit of the federal Hours of Service Act (twelve hours).

*Dispatcher*   The equivalent of an air traffic controller for trains, the dispatcher operates power switches and controlled signals in a specific territory and issues train orders and train bulletins.

*Dog*   A train that isn't going anywhere fast—one that has no priority with the dispatcher.

*Double head-ender*   A car that should be placed during switching in the second "block" from the head end of a train. Each block of cars in a train has a different destination en route.

*Double over*   To pick up a whole track and couple it to another whole track; of working: to work two shifts in twenty-four hours.

*Drop a dime*   To make a call reporting a fellow employee to management for violating the rules.

*Drawbar*   The wrench-shaped piece of metal that the knuckle fits into. The drawbar is the heaviest component of a coupler and the part that remains rigid; it often takes two people to adjust it. If you break a drawbar as well as the knuckle, you have really hit hard.

*Drag*   See *Dog*. A train may also be called a "pickup drag" when it must stop at many places to pick up freight cars.

*Dynamics*   To "throw into dynamics" is to use the power generated by the engine's electric motor to assist in braking.

*Engine service*   The engineer's craft.

*Extra board*   A list of the available brakemen or switchmen. As each brakeman is called for a job, the next in order moves up to first place and is then "first out" to be called. The board rotates: when a brakeman reports back in from a job, he or she goes to the bottom of the list.

*Field man*   The brakeman or switchman who works the position farthest from the engine, something like a center fielder.

*Fireman*   An apprentice engineer. In the old days, being a fireman was a separate craft that involved stoking the steam engines.

*Flat switching*   Classifying cars by using the engine to propel them and then cutting them off while they are in motion and letting them roll onto various tracks. Flat switching is opposed to "humping," in which the cars are on an incline (the "hump") and not much momentum is needed to get them in motion. Flat switching is a skill requiring expert timing and a knowledge of how the cars are going to roll on each rail in the yard.

Novice foremen often don't kick cars hard enough, which can cause them to roll back out of the tracks or stop in places where they are blocking other tracks. Or else they kick cars too hard, sending them smashing into other cars on the track, derailing them, or breaking drawbars.

*F.R.A.*   Federal Railroad Administration.

*Fusee*   A road flare that burns for ten minutes, used in signaling.

*Get together*   See *Couple up*

*Head-ender*   The first car in a train.

*Herder*   The switchman who guides engines and trains in and out of a yard, lining switches and giving them a highball with a green flag or a green light. The herder at the top end of the Watsonville yard was called a bull-ringer, from the slang term for an engine—a bull.

*Highball*   A signal meaning "get going" or "all's well with your train."

*Hole*   "In the hole" means that a train is on a siding waiting for a train on the main line.

*Hoghead*   An engineer—as in the "Hog Law," for the Hours of Service Act.

*Home terminal*   The place where you hired out.

*Hotshot*   A fast freight that has priority on the main line.

*House*   The roundhouse: the storage and maintenance facility for engines.

*Hump*   A man-made hill in a classification yard. The hump allows cars to be separated from each other using gravity. A cut of cars is shoved to the crest of the hill, the pin on several cars is pulled, and those cars roll down off the hill into one of the bowl tracks at the bottom. The process—called "humping"—is repeated until all the cars in the cut have been separated.

*Interlocking signal*   An absolute signal, usually placed at the entrance to a yard, that governs movement into a main line.

*Intermodal flatcars*   A unit of five flatcars linked together, used to transport containerized freight or truck trailers.

*Joint*   A coupling between two cars—as in "make a joint. When you are "making joints" while getting a track together, you are closing up the gaps between cars so that the entire train can be pulled out. An obvious gap in the rail indicates that a joint needs to be made. A gap deep in the rail is referred to as a "long joint," meaning that it is at a great distance from the first car in the rail. A "short joint" is a gap closer to the first car.

*Kick*   To shove cars along ahead of the engine so that when the engine stops and the cars are simultaneously uncoupled from it, the cars will roll into a track on their own.

*Knuckle*   The mobile component of a coupling device, weighing eighty-five pounds. Two knuckles lock together to form a joint, or couple. Knuckles

are the weakest link in a coupler and often shatter when a train breaks in two. See also *Drawbar*

*Lace a train*   To manually connect the air hoses between all the cars in a train prior to turning the valve on the engine that fills them with ninety pounds of air pressure.

*Lay off*   To take time off.

*Layover*   Time between runs away from home.

*Lead*   A yard track from which other tracks branch off. A lead track will typically have ten other tracks feeding into it.

*Line up*   To arrange the way the switches are lined in a specific sequence that provides a clear path for the movement of the train.

*Local*   A job in which one goes off duty at the same place one went on duty and works a local run.

*Long joint*   See *Joint*

*Make the air*   See *Lace a train*

*Old head*   A rail with a lot of seniority.

*On call*   To be available for work. Brakemen and conductors are on call twenty-four hours a day. Switchmen are on call three hours ahead of each yard shift.

*Outbound yard*   The portion of the yard where main-line trains assembled by switchmen await train crews to put the engines on.

*Out of service*   Refers to someone who is being held off-duty as a disciplinary action.

*Overtime shift*   The second eight-hour shift in a twenty-four-hour period.

*Passing signs*   Before handheld radios, crew members positioned themselves to relay hand signals to the engineer. This often entailed getting on and off cars to find the proper vantage point as the cut of cars moved around corners.

*Personal leave days*   Days off with pay, corresponding to sick days.

*Pickup*   Specified cars that are to be added onto a train.

*Pickup drag*   A local freight job that picks up cars in a number of locations and brings them back to its home terminal.

*Piggyback train*   A train consisting of intermodal flatcars, which usually carry containerized freight.

*Pinpuller*   A switchman who works the position closest to the engine, lining up the switches ahead and operating the uncoupling (cut) lever on the side of cars during switching.

*Plug the train*   See *Big hole*

*Pony*   Engine.

*Pool freight*   Refers to the pool of crews, available in a rotating order, to work on through freight trains.

*Press a train*   To squeeze cars together on a track, usually after setting the air brakes. This pushing against the resistance of the brakes takes up the excess slack between the cars, allowing more of them to fit on a track.

*Pull*   One of the two possible maneuvers involving an engine and cars. You either pull the cars behind the engine or shove the cars ahead of the engine. You either pull a track or shove a track.

*Pull a car*   To remove a car from its location on an industry track.

*Pull the air*   See *Big hole*

*Pull the pin*   To uncouple something—and, by extension, to quit the railroad, to quit anything, to die.

*Rail*   A railroader; also what the railroad runs on.

*Receiving yard*   The portion of the yard where main-line trains pull in and stop. The cars are left on the tracks to be "bled off" by the car department and then switched out by the switchmen.

*Reduce a train*   To remove a block of cars from a train, usually using a switch engine.

*Roll-by*   Observation of a passing train for possible defects.

*Roundhouse*   The facility where engines are worked on, most commonly a round brick building with lots of windows.

*Runaround*   A parallel siding track used to detach the engine from the head end of a cut of cars and put it at the rear of the cut so that it can move the cars in the opposite direction.

*Sand*   To release sand onto the wheels of the engine to provide traction on inclines.

*Seniority*   The most important qualification for any job. Seniority is based on the date you hired onto the railroad and the number you pulled out of a hat when the members of your class drew lots to establish their seniority order.

*Seven-day stand*   A job away from your home terminal that lasts for seven days.

*Shove*   To push cars ahead of engine. See *Pull*

*Skate job*   An easy assignment: a one-man switchman's job that involves putting a metal block called a "skate" under the wheels of the first car in a track to prevent the cars from rolling out. The first car in a bowl track is usually skated so that cars may be humped into the other end of the bowl without causing cars to be shoved out onto the bowl lead.

*Slack*   The six-to-eight-inch span of free play built into couplers. When a

cut of cars is stretched, you can hear the slack running out in a chain re-action.

*Spot*   The exact location on an industry track to which a freight car is to be delivered. "To spot" is to place the car exactly where it belongs. To go "on spot" is slang for taking a break.

*Switch list*   A computer-generated list that gives the identification numbers of the cars on a particular track, along with their destinations. The yard-master then marks the list by hand to indicate to the switch crew how the work is to be carried out.

*Switchman*   A railroader who works in a yard, as opposed to one who takes trains out on the main line. Switch crews now consist of a foreman and a helper. They put cars together to form trains and break trains down into separate cars, and they do the work of classifying cars. Switchman work regular hours on a three-shift schedule. In the old days, there was rivalry between switchmen and brakemen. When I hired out I was constantly asked, "Are you a switchman or a brakeman?" There was only one right answer.

*Stretch*   An order to the engineer to pull on a cut of cars to see whether they are coupled up.

*Tail track*   A track where switches have been lined to accommodate your movement so that you can back into this track when you're pulling cars behind the engine.

*TBM*   Acronym for "train baggage man."

*Tell tales*   A series of ropes hung from a transverse line a sufficient distance before a low bridge or tunnel that are used to alert trainmen "riding high" on the tops of boxcars. The ropes would strike the men, thus warning them to get down.

*Tie 'em down*   To tie the hand brakes on a cut of cars.

*Timekeeper*   The person in charge of pay.

*Train*   An engine or engines, with or without cars, displaying a marker (a red light at the rear). A track full of cars is not a "train" until it has an engine, whose number gives the train a specific identity, and a defined length.

*Trainmaster*   The company official who is in charge of a terminal. He typi-cally hides in bushes and pops out to ask arcane questions about the Book of Rules.

*Trim*   The switching job that involves work on the bowl tracks below a hump—usually coupling up the cars and throwing out "bad orders."

*Triple head-enders*   The block of cars third-out in a train.

*Tube*   A list "in the tube" is a switch list dropped through a pipe from the yardmaster's tower. The foreman walks under the tower to retreive it.

*Turn*   To "turn a car" is to reverse the spacial relationship of that car to another car—for example, to place the second-out car on a rail in first-out position. A "turn" also refers to a local freight job that goes from its home terminal to a specified location and returns, as in "the Mission Bay turn."

*Turnover*   A report the yardmaster completes before ending his shift.

*Unit*   Engine.

*Yard*   The place where freight cars are classified.

*Yardmaster*   The person in charge of all movement within yard limits. The job of yardmaster is a seniority-based position that switchmen bid on.

Library of Congress Cataloging-in-Publication Data

Niemann, Linda.
   Railroad voices / narratives by Linda Niemann ; photographs by Lina Bertucci.
      p.   cm.
   ISBN 0-8047-3209-4 (alk. paper)
      1. Railroads—United States—Employees.   2. Railroads—United States—
Employees—Pictorial works.   I. Bertucci, Lina.   II. Title.
HD8039.R12U66   1998
331.7'61385'0973—dc21                                                    98-5970
                                                                              CIP

∞  This book is printed on acid-free, recycled paper.

Original printing 1998

Last figure below indicates year of this printing:
07   06   05   04   03   02   01   00   99   98